HELAMAN FERGUSON

*To Ray & Della Glenn,
with affection, and
warm regards,*

Claire Ferguson

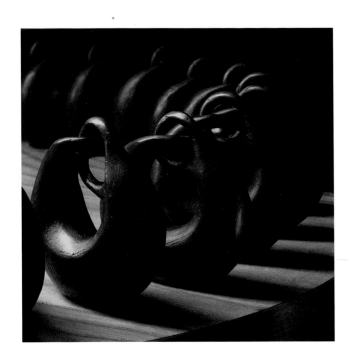

HELAMAN
FERGUSON

MATHEMATICS IN STONE AND BRONZE

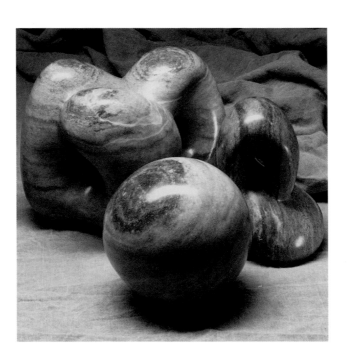

DEDICATION

To our seven sometime hours
of unbridled passion become
seven lives of living love:
David then Heidi then Seth, Sam,
Ben then Annie, Sarah Noelle, Jonathan,
Alexander, Michael

Published by Meridian Creative Group

Acquisitions Editor: Jill Larson
Production Editor: Andrew Scott
Project Manager: Michele Bliss
Designer: Chuck Benson

Author: Claire Ferguson

Photographer: Ed Bernik, Erie, Pennsylvania

Additional Photo Credits: Cosby and Bower, *Figure Eight Complement II*
Kenneth Olson, *Thurston's Hyperbolic Knotted Wye II*
Mark Philbrick, *Wild Singular Torus, Whaledream II*
Greg Porter, *The Eight-Fold Way*

Color Separator: Digicon Graphics Inc., Buffalo, New York

Printing: Broudy Printing Inc., Pittsburgh, Pennsylvania

Copyright © 1994 Meridian Creative Group

All rights reserved. No part of this publication may be reproduced without the written permission of the publisher.

Any inquiries should be directed to:

Meridian Creative Group
5178 Station Road, Erie, Pennsylvania 16510
(814) 898-2612

Manufactured in the United States of America

ISBN 0-9639121-0-0

FOREWORD

F O R E W O R D

Helaman Ferguson is an artist who uses mathematics to create his work, or, also true he is a mathematician who uses art to create his work. Such is the conundrum, and joy, of experiencing the sculpture of this artist. His art is rooted in the duality of mathematics as both art form and science. He combines mathematical concepts and ideas with equally compelling aesthetic ideas and concepts. Viewing his work, we experience sculpture that is visually abstract, biomorphic in feeling, and made of traditional sculpting materials, but instinctively we sense a logic and order beyond one artist's vision, a deeper truth of structure made material and tactile.

Art is often referred to as the universal language. Combined with the universality of mathematics, the art of Ferguson doubly echoes this thematic possibility of global communication. Described in mathematical language, his fundamental images are tori and double tori, nonorientable surfaces, Mobius strips, trefoil knots, wild and tame spheres, and cross-cap surfaces. Even these simple terms of topological mathematics, and certainly the equations he uses to create these spatial forms, go well beyond the layperson's understanding or even desire to understand. They are terms comprehended by the mathematician, and terms of esoteric mystery to the rest of us. But the physical reality of his sculpture is mathematics experienced in three dimensions, an object placed in our tactile sphere of comprehension. No longer are mathematical equations or concepts beyond our reach, they are placed at our fingertips and made visually intriguing and satisfying. We understand the mathematics with an intuitive insight as even the descriptive terminology conjures up enigmatic possibilities.

Described in art language, his sculptures are abstract images. They are biomorphic, organic forms that incorporate strong elements of repetition, pattern, making strong use of the void and of the crucial interplay of positive and negative space. He uses the natural colors of steatite, alabaster, and marble, with a wrought-hewn matte surface or highly polished reflective surface, or bronze finished with various patinas. The language of art can also be as esoteric as mathematics and also go beyond the layperson's understanding. But his sculpture draws on humanity's desire to see its own reflection, his biomorphic forms create instant identity with biological growth, family organization, and bodily associations. His sculpture is sensuous, and we respond directly to this feeling of sensual involvement. The universal languages of mathematics and visual art reach beyond written works or verbal explanations, and the art of Ferguson aptly demonstrates the power of this universality when used for the clarity and sensual beauty possible in the two disciplines.

Mathematics as art, art as mathematics: the melding of these two very different disciplines is the essence of Ferguson's sculpture. For most people there is an automatic reaction to the mention of mathematics in art implying a coldly-reasoned construction, and an equally automatic response to art in mathematics of disavowal. To view and experience his art, both assumptions grow weak and disappear, for his work is neither cold nor incomprehensible. It is impassioned and beautiful, stimulating to the eyes and the mind.

The artist has stated, "I use mathematics as a powerful aesthetic design language for vital archetypal images. My creative processes include the transfer of thought forms to physical materials. I respond to aesthetically motivated concepts embodied in mathematical languages of varying choices of abstraction." Although abstract, his objects are strangely depictive, concrete images of mathematical musings.

As abstraction has become an accepted part of our postmodern visual language, it no longer dominates avant-garde imagemaking as it did at the beginning of this century. But, rather, abstraction retains its meaning for us as one approach, among others, to artmaking, and as a synthesis of the legacy of modernism with our own postmodern and some would even say post-postmodern, concerns. Abstraction in all its forms and variations remains a powerful force in today's art, and nowhere is this more strongly realized than in today's sculpture. Unlike painting, sculpture presents us with real, three-dimensional objects. When abstract, these objects gain visual strength from this physical presence. Clearly the iconography of his oeuvre and the individual sensibility evident in Ferguson's abstract sculpture place his art within this arena of contemporary art.

In spite of his use of exacting mathematical equations and content, his sculptures are not rigid geometric configurations nor are they mathematic illustrations. The artist chooses to use these mathematical ideas to create objects that are warm and humanistic, deliberately using forms that embrace the human element, even with a bit of whimsy at times. He works in bronze and stone, embracing the traditional materials of sculpture to lend the works a felt relation to previous sculpture and an accessibility for the viewer. This use of materials that are familiar and inviting further accentuates the artist's desire to heighten the sensory experience, for his sculptures are extremely tactile and very tempting to the touch. He is equally at ease using the time-honored methods of hammer and chisel, to a modern pneumatic hammer, to computer-assisted imaging sculpting. He continues to explore the use of scientific visualization and computer-aided manufacturing to make visual his creative concepts, placing his artmaking methodology at the forefront of technological advances. This combining of art with the latest technology seems to make his art all the more human.

His forms are the result of an inseparable interrelationship he has made between mathematics and art as he has made visible his own "thought forms." Perhaps the artist has found a way to visualize Jungian-like archetypal images through his own particular use of mathematics. In Claire Ferguson's essay on one of his sculptures, she describes it as an archetype existing in a "province of perfection, meditation, and pleasure." Indeed, all his sculptures seem to exist in this special province. Even without the esoteric knowledge of the world of art and mathematics, the viewer of these sculptures is drawn to this realm of aesthetic enjoyment and philosophical contemplation. Such is the evocative power of these abstract images.

Helaman Ferguson is both artist and mathematician. The art historian Herbert Read saw the mathematician as an abstract artist "except that he does not possess, or has not cultivated, the ability to express his conceptions in a plastic material." Ferguson is exactly that abstract artist who fully possesses and has cultivated his ability to express his mathematical conceptions as sculpture. He has discovered the common ground of mathematics and art upon which he has placed his own creativity.

Richard Waller

Richard Waller is currently director of the Marsh Art Gallery, University of Richmond, Virginia. A graduate of Yale University and formerly of The Brooklyn Museum, he has curated many exhibitions of contemporary artists and written extensively on recent art.

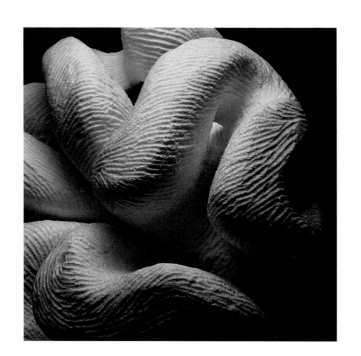

PREFACE

P R E F A C E

Helaman Ferguson is a sculptor who clothes mathematics sensuously in stone and bronze. As a mathematician, the sculptures he creates are unique because the forms he envisions are not abstractions rooted in visual reality, but graceful reflections of pure reason based on a body of knowledge of consistent patterns.

Granted, I'm not remotely objective, but I do share a personal understanding of the motivations of the artist. I have access and my enthusiasm should cover a multitude of subjective viewpoints.

Why am I excited by these sculptures? Think of the broad categories of art; realism and abstraction both derived from nature, nonobjective and emotive from the subconscious. Helaman takes the symbols of abstraction, and combines them with non-mimetic, elegant forms which incorporate the intuitive. Art has traditionally been based in the written word, in religious, mythological or political literature reflecting its time and place. Helaman's sculpture is based on the symbols of a language more fundamental than words, symbols invested with laws of their own, and inaccessible to most of us. Here then, emerges a whole new genre which bears some conceptual relationship to the tiles of the Islamic world of abstract forms but which is activated by humanism: the curiosity which led to scientific observation and inquiry and that characteristic fascination with the human body which powered the Golden Age of Greece and the Renaissance. The crucial difference in Helaman's work and his means of communicating the esoteric essence of an abstract theorem warmly to the viewer, is his constant reference to the human body.

The content of his work is unique. The theorems discovered millennia ago still form the basis for our present advances as well as for those of the future when new relationships will be perceived resulting in a paradigm shift in mathematics with unpredictable spin-off applications, once again proving the unreasonable effectiveness of mathematics in science. The mathematical sciences possess a rare beauty of their own, until now largely unrevealed to the naked eye. As the exact sciences have the power to quantify the laws of nature, so art has the power to move the soul. Those theorems which he and others in the mathematical sciences know to be singular, elegant and important can be understood as a celebration of the human spirit. They affirm the worth of individual contribution to the body of knowledge and humanity's capacity to free itself from the superstition and tyranny which has held it bound from its potential. Helaman is communicating the numinosity of these ideas in his sculpture, integrating the careful, rational disciplines and a romantic, emotive celebration of the imagination. I am convinced of the importance of this sculpture and of the mathematical concepts underlying them. Those ideas which undergird the mechanical functioning of our lives have their basis in mathematics. Beautiful and invisible, they deserve to be transmitted in order to awaken our awareness, overwhelm us with beauty and inspire a challenge to the terror we feel in the presence of higher mathematics.

As for the question of what motivates him, I believe it is partly his love and devotion to this Queen of the Sciences, excitement in her deep significance and desire to communicate her splendors. He loves the sheer physicality

of carving, the power over an impenetrable substance formed after millions of years into something which appeals to aesthetic senses. Taking a piece of rock you would probably have passed without noticing and transforming it to represent our culture's highest achievements gives him profound satisfaction, a physical counterpoint to the concentration of mathematical creativity.

Finally, I at last have my say about those vibrant forms which at once thrill me and rival my claims to my husband's time. As an active participant, lover, nurturer and model, I have observed the development of his mathematical and sculptural trajectory. A friend inquired, "Why does he do sculpture?" I replied, "Just try to stop him; it's like trying to change the weather." From the traumatized three-year-old who saw his mother killed by lightning to the idealistic twenty-two-year-old I married and beyond, I have witnessed the emergence and maturation of a remarkable sculptor.

Helaman has had his studio home-based for most of the twenty-seven years he has been sculpting, which gave me and the family circus of seven children raging around him, access to the process from the beginning. It has been my privilege to curate a number of his shows, and be vitally involved in the birth of each piece. As an artist, I have found the journey tremendously exciting. There has never been a dull moment, but there have been lots of dusty ones.

The mathematical analysis of the pieces was gained from interviews with him which often lasted for hours as I tried to translate some of the import of each sculpture into words. Upon completion, Helaman also proofed my manuscripts for mathematical ac-

curacy. And yes, I have been trained to accept any outlandish schedule as perfectly reasonable as well as any incredible combination of clothes.

The symbolic content of his work is unique, expressing truths which heretofore have only existed in the mind. The visual and tactile expression of his work is stunning and uplifting. Theorems mathematicians consider singular, elegant and profound possess their own beauty; I have glimpsed it in these voluptuous, tangible three dimensional sculptures shining in enduring materials and have been moved.

Claire Ferguson

October 15, 1993
Laurel, Maryland

$$cxy^2 + dy^3$$

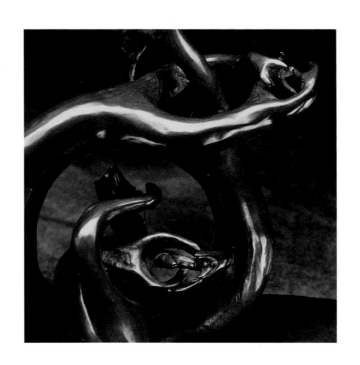

CONTENTS

THE WORK

Cosine Wild Sphere

ALBEMARLE SERPENTINE, 18" x 14" x 6"

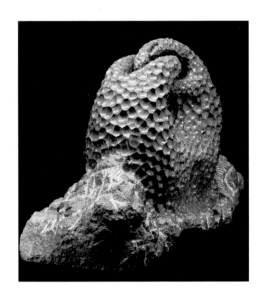

The black stone appears to be composed of hundreds of gleaming points of light. Coming across the room toward *Cosine Wild Sphere*, one perceives the piece as a mass of convexities and is astounded to discover that it is a mass of prickly concavities instead. When the illusion registers, the initial reaction is one of disbelief.

The use of differential light has been exploited here as a defining element. Highlights reflecting from a solid mass dissolve the surface tension, fragmenting the space inhabited by the object and the space surrounding it.

Fundamental functions of trigonometry, cosine and sine curves look identical, shadows of those warm human forms which nourished us. For this torus, Helaman Ferguson extracted a piece of the cosine curve which then became the cross-section of the torus. This cosine torus was incised into a wild sphere form. The sphere has bifurcated three times, splitting from the base into two, four, and finally eight branches, referring to an infinite generational process. The polished spheres get smaller as the division continues to articulate the limbs. As the sculptor explains, "one most interesting and unnatural thing about modern mathematics is its preoccupation with infinite processes. This incised wild sphere is a multi-armed confinement of an intimate process."

Cosine Wild Sphere emerges from rock like Prometheus from his chains. The base which melds roughly into the wild sphere is marked by claw marks left by a toothed chisel. Ferguson left the raw rock to expose its 250 million-year-old history. The split stone face of the base lies in sharp contrast to the jewel-like polished spherical pockets which were carved by a variable sized, rotating tungsten carbide ball. With *Cosine Wild Sphere*, Ferguson has used the opposition of light and mass to create a sculpture that tantalizes the vagaries of vision.

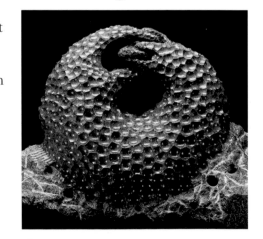

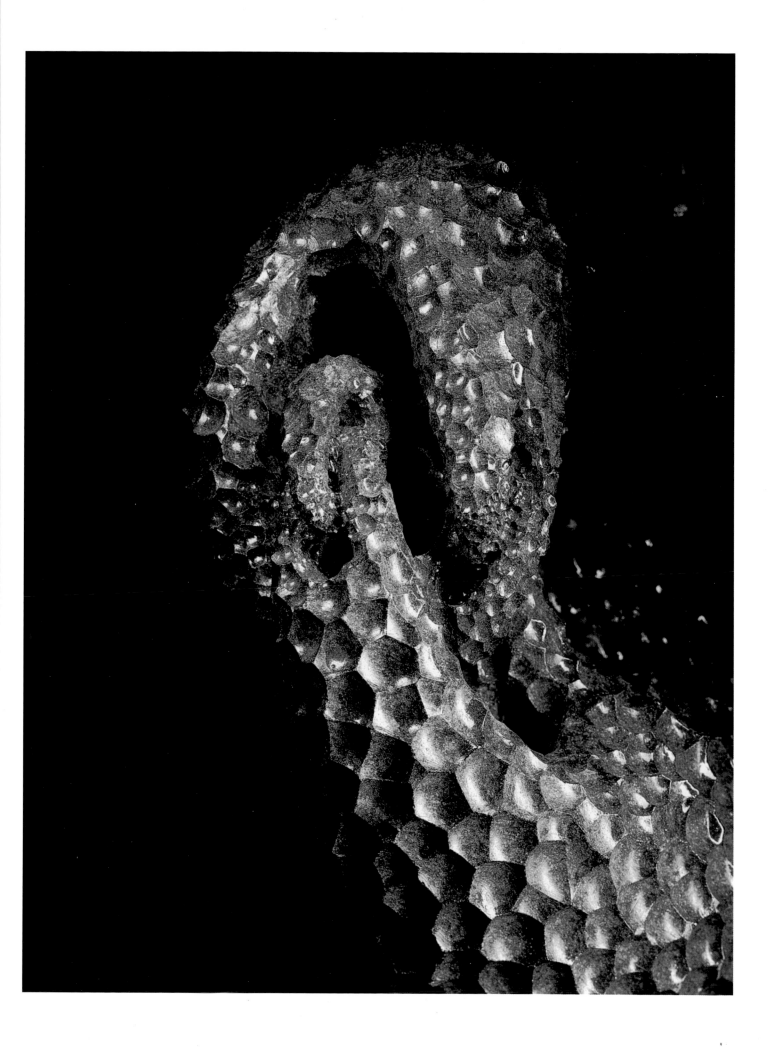

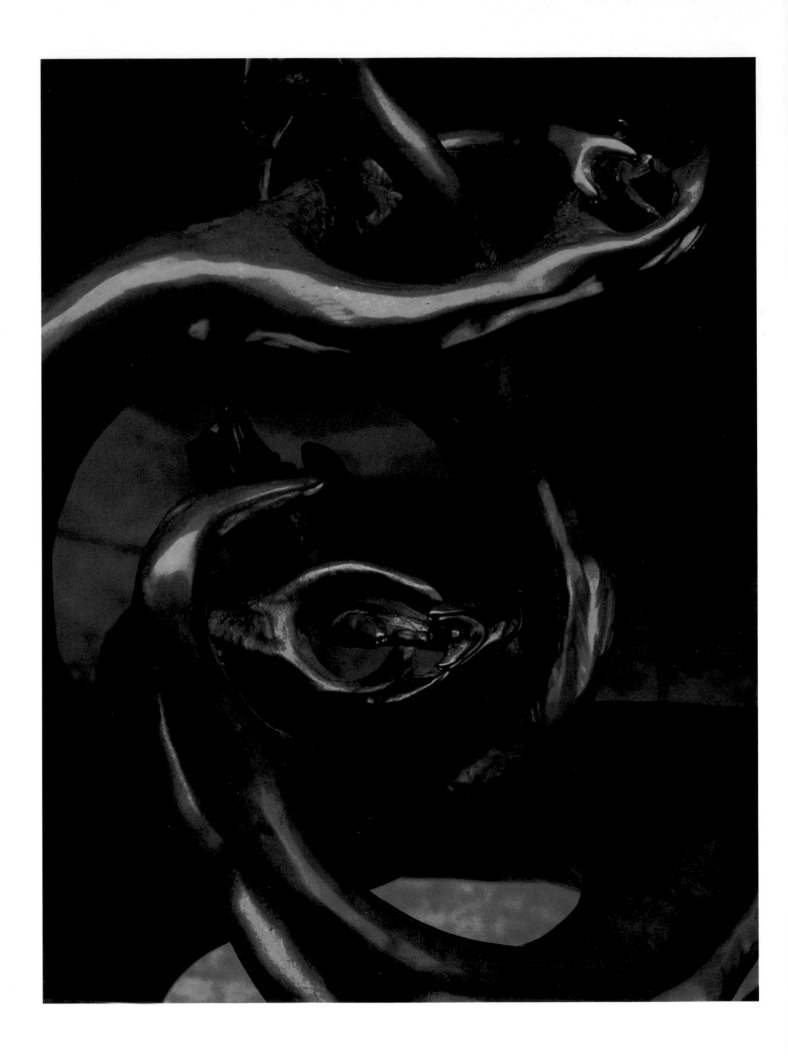

Alexander's Horned Wild Sphere

SILICON BRONZE, 7" x 7" x 12"

The crock pot disappeared silently into the sculptor's studio in 1986, where it was used to melt casting wax, integral to the taming of the *Wild Sphere Series*. Ferguson formed a ball of the warm wax and began squeezing out horns. From the first two he pulled out

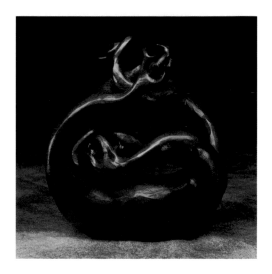

two more, and from that set, two more, bifurcating each horn until the wax couldn't stand it anymore. No wax was added or subtracted — only deformed. At any stage he could have squashed it all back into the wax ball, which is in its own way a proof of the wild embedding of a sphere.

Princeton mathematician, J.W. Alexander conjectured a theorem that stated that a wild sphere cannot exist. Meanwhile, another mathematician, L. A. Antoine had published an example of a wild embedding of a sphere, without an illustration. Alexander immediately renounced his conjecture and in the "Proceedings of the National Academy of Science," published an illustration and referred to Antoine's work. Thereafter, the theorem became known as *Alexander's Horned Wild Sphere*, confirming the time-honored mathematical tradition of naming theorems, which usually follows a pattern of naming it after X because it was written up by Y and discovered by Z.

Mythologically, the wild sphere reenacts creation. First, in the creation of the cosmos comes the framing of Space (the sphere). Second, is the production of life within the frame (the branches).

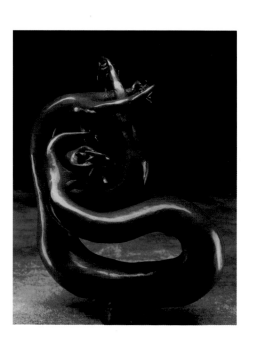

At the base of the bronze tree are the parents — the first bifurcation, their children — the second, their grandchildren — the third, their great grandchildren — the fourth. The generations continue infinitely in the ambient space beyond the sculpture. Their lives are intertwined with one another, but separate, allowing the growth of the individuals, as well as the branches. The arms encircle each other sensuously, reaching upward, embracing, loving.

Umbilic Torus NC

SILICON BRONZE, ANTIQUE GREEN PATINA 27" x 27" x 9"

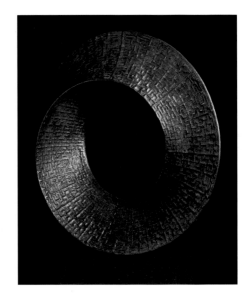

The form of *Umbilic Torus NC* is a continuous, donut-shaped surface patterned with a space-filling curve. It stands as a monument to the timelessness of man's creativity as though it had just been unearthed with painstaking care from a Chinese tomb or an Egyptian pyramid—its Faience-tinted bronze corroded by centuries of silent waiting. The space-filling curve is as mysterious as the Chinese calligraphic script or Egyptian hieroglyphics — flowing over the surface, defining it, beginning at any point and meticulously returning to that point after traversing every inch of its area. The form of the space-filling curve is universal, known from the earliest architecture and ornament. The angles of the space-filling curve play a harmonious counterpart to the torus, or ring, which has always signified unbroken love.

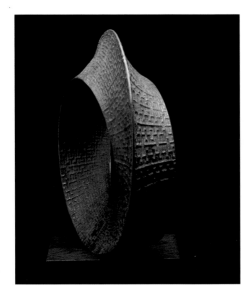

Umbilic Torus NC imbues its viewer with a sense of comfort and peace, reminiscent of the work *Bird in Space* by the sculptor Constantin Brancusi, who sought to express an inner reality lying beyond the surface of the physical world. "Simplicity is not an end in art, but we arrive at simplicity in spite of ourselves as we approach the real sense of things. What they think to be abstract is the most realistic, because what is real is not the outer form, but the idea, the essence of things."

Like Brancusi, Helaman Ferguson uses the nature of the material itself to become part of the work's meaning and expressiveness. The ancient lost wax bronze casting process, cire perdue, was the method used to cast the early bronzes of all civilizations. Used to create this piece as well, it contributes to the viewer's sense of continuity with the past. Helaman Ferguson's art embodies essential truth, mathematical theorems, which he takes from the spiritual realm of pure reason and clothes with forms accessible to us all.

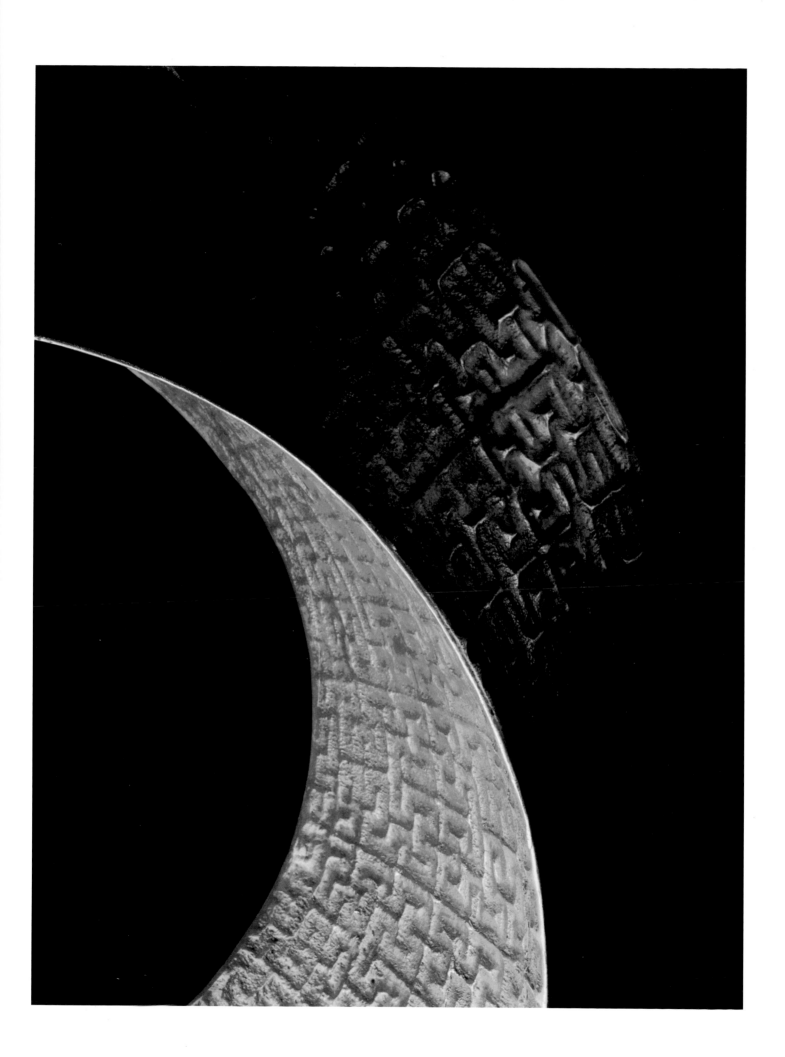

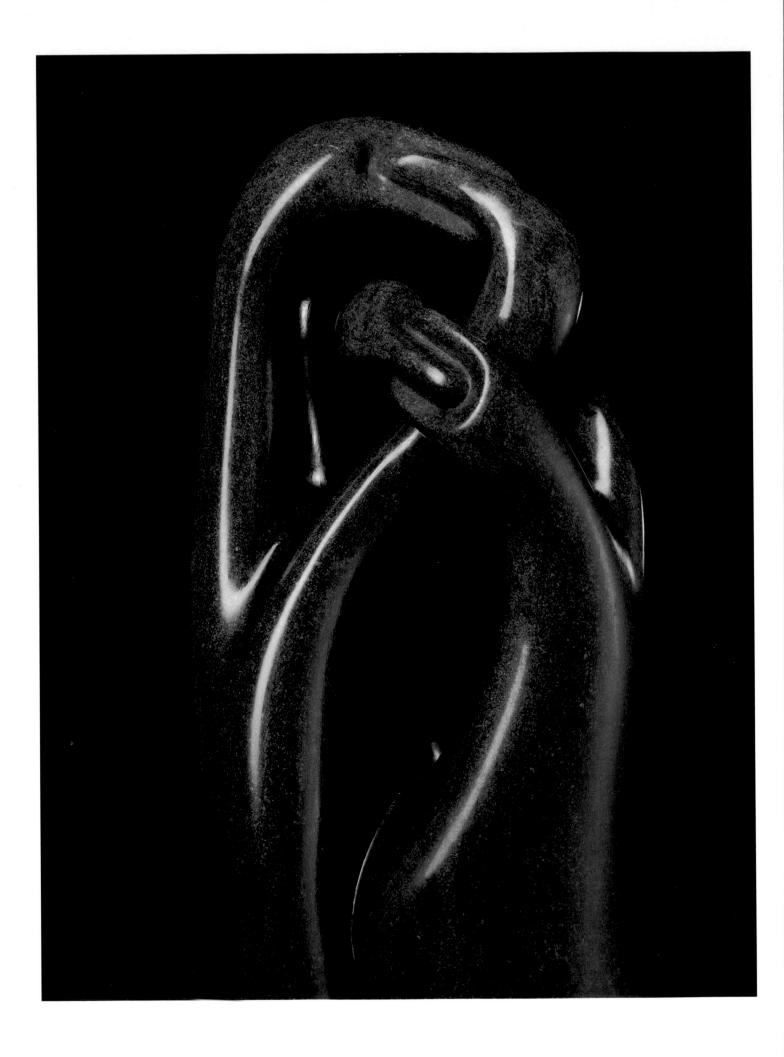

Whaledream ii+i Wild Sphere

POLISHED BLACK STEATITE, 32" x 14" x 11"

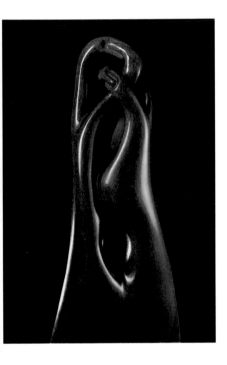

The intertwined forms of *Whaledream ii+i* belie the stereotypical image that mathematically based art is cold and calculated, particularly because it models parts of the human form. Extending the tradition of Michelangelo and Auguste Rodin, who expressed emotion through the human physique, Helaman Ferguson here represents a concept through abstracted sensual shapes — mysterious and provocative, playing to one's senses like Rodin's *The Kiss*. According to Rodin, "The sculptor must learn to reproduce the surface, which means all that vibrates on the surface, soul, love, passion, life ... Sculpture is thus the art of hollows and mounds, not of smoothness, or even polished planes."

The surface of *Whaledream ii+i* is invested with vitality. It is comprised of vertical branches penetrated by holes which lead one's eye upward from the base to the intricate branches at the summit. The dark polished curves of *Whaledream ii+i* catch the play of light suggesting the fluidity of living flesh. The ancient stone, steatite, which produces this impression, has been prized by sculptors for centuries because of its polish.

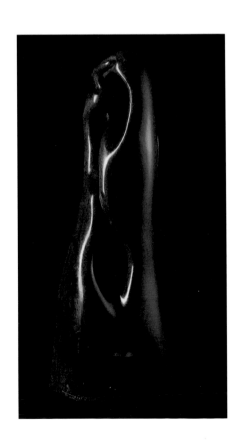

The power of this work's presence arises from the tension between the interwoven arms — the negative space between them carries much of the visual weight. Ferguson has incorporated the human element to express the vision of infinity. *Whaledream ii+i* expresses this image in two ways: the bifurcations at the top, which represent the continuous branching of growth, and the closed circle below, which is one eternal round.

As with each of Helaman Ferguson's sculptures, *Whaledream ii+i* is the embodiment of an idea, repeating the cycle of man's creativity through art — representation progressing to concepts. The genius of this piece is Ferguson's literal incorporation of the familiar to convey the ethereal relationships of mathematics.

Eine Kleine Rock Musik III

HONEY ONYX, 15" x 18" x 7"

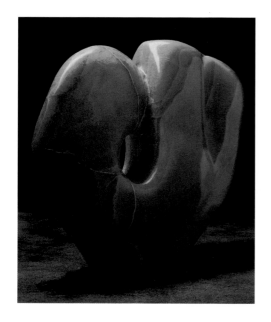

This sixty pound piece of honey onyx was quarried by the sculptor in Utah, where prospecting is not an uncommon avocation. Helaman was guided by two fellows who had modified a four-wheel drive truck with two fifty-five gallon oil drums. Each weekend for ten years, the two had driven into the Great Salt Lake Basin to prospect for uranium. Their method was to drive until one tank ran out, then turn toward home. Over the years, they had found everything but uranium — including an outcropping of onyx — the end of a barrel-shaped vein crushed by the weight of a mountain.

Inspired by the mathematics of a Klein bottle, Helaman Ferguson sculpted the quarried stone into *Eine Kleine Rock Musik III*. A Klein bottle is one of four fascinating ways to sew up a square. Actually, it is not a bottle at all, but a non-orientable surface — two moebius bands joined together. On such a surface a right-handed bug would go for a walk and come back left-handed because it would actually be flipped over without realizing it. The name "bottle" was mistakenly assigned to the surface because the German word for surface, which sounds like the word for flask, was mistranslated as "bottle." Ironically, the sculpture looks vaguely like a pitcher without a spout — perhaps an avant-garde design in which a cleft replaces the nozzle.

A Klein bottle is a self-penetrating form — its surface passing into itself and re-emerging on the other side. The cream-veined salmon onyx is translucent in the line of the cross-cap or cleft — the emerging light provides the focus of the piece counter-balancing the negative space of the hole. As the artistic spirit works by contrast or counterpoint, so this sculpture marries the analytical to the subjective. The Klein bottle is conceptual, it doesn't quite exist in real physical space, but Ferguson's *Eine Kleine Rock Musik III* has brought it quivering to the threshold of reality.

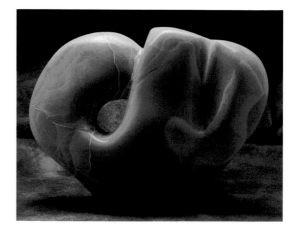

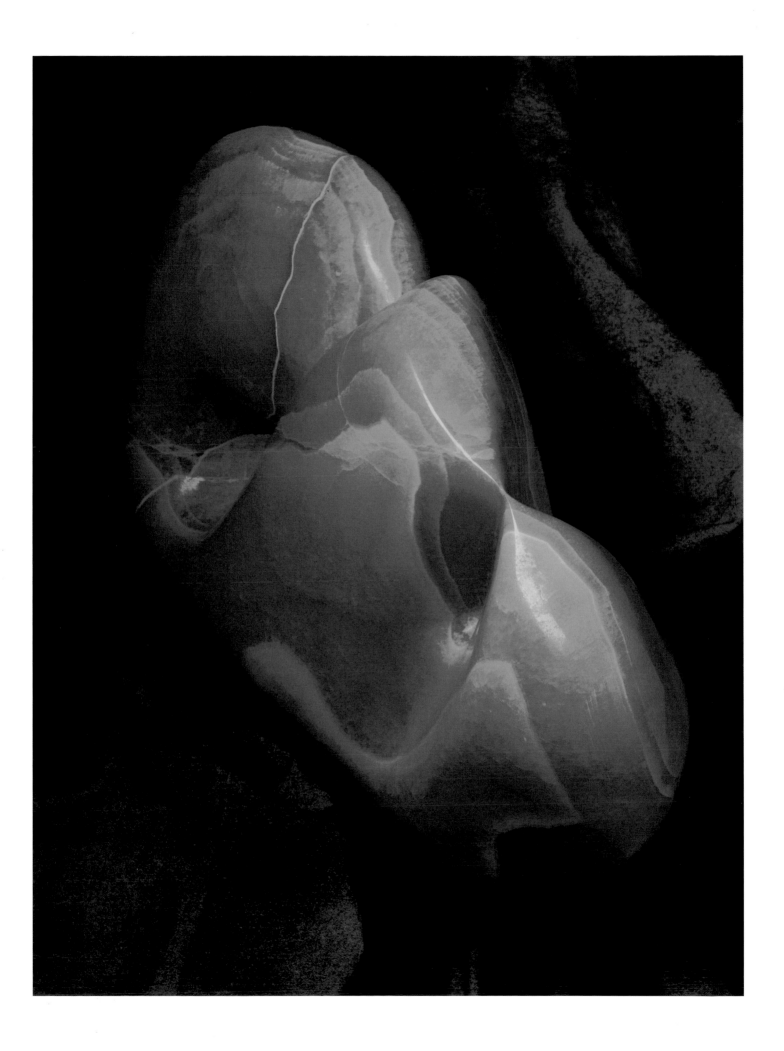

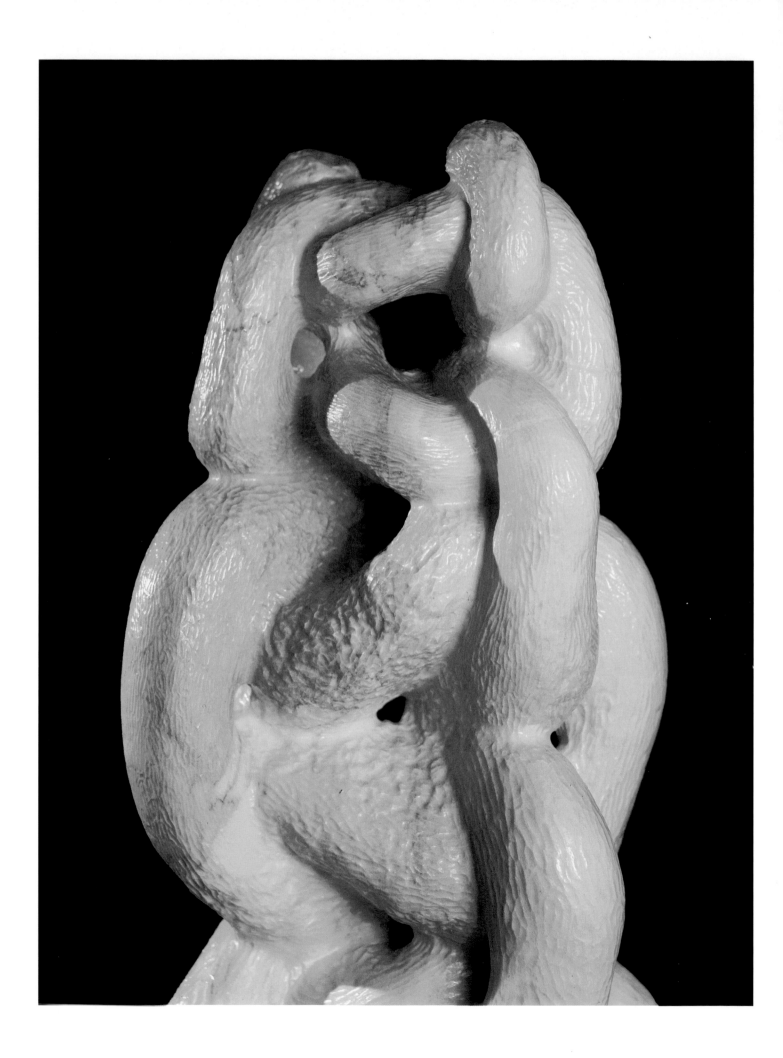

Wild Singular Torus

WHITE CARRARA MARBLE, 62" x 22" x 18"

A little over five feet tall, *Wild Singular Torus* is a one-thousand-pound column of white carrara marble, carved with a rope-like texture into an intricate series of knots. It stands as a solid mass of curves and hollows, like Rodin's *Balzac* — only a few penetrations make their way entirely through the solid stone. The idea that the sculpture projects into reality is that of two strands, infinitely intertwined upward. That being impossible in physical materials, however, they are severed prematurely at the top, exposing the raw rock. If allowed to continue knotting, the strands would continue like Zeno's paradox, approaching but never meeting a point about two feet above the broken rock.

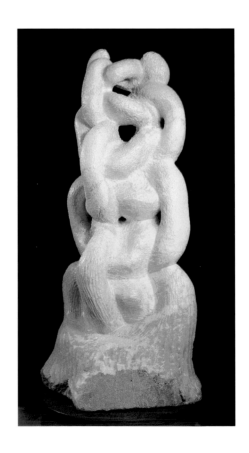

Mythology and religion traditionally supply the symbols which bear up the human spirit, providing subjects for artists. As a symbol of continuous creation, *Wild Singular Torus* speaks of Earth's navel — eluding to the mystery of the maintenance of the world through the continuous miracle of vivification, which wells within all things. It reflects a mythology of science, a concept of continuous growth, of infinity.

As a weaving, the rock recalls a prehistoric activity undertaken in the protection and fellowship of the hearth, its stone fabric symbolizing the intersection of lives against the threat of death which will ultimately rend them apart. Helaman Ferguson's sculpture conveys a permanence and stability which reaches into the viewer's space by the power of its sheer mass.

Torus will endure well beyond the fragile present.

Torus with Cross-Cap

POLISHED BRONZE, 10" x 7" x 3"

Leonardo da Vinci conceived the plan of observing all objects in the *visible* world, recognizing their forms and structure and pictorially describing them as they exist. Helaman Ferguson, on the other hand, conceived the plan of observing objects in an *invisible* world, recognizing their forms and structure and encapsulating them in tactical, visible figures which he endows with sensuous beauty. These are not mathematical models but the manifestation of the highest abstractions of human thought.

Says Ferguson, "the creative mathematician part of me understands higher mathematics as an art form; a spiritual discipline and conceptual creation motivated by abstract beauty and validated by logical truth. The creative sculptor part of me transforms certain mathematical events with millennia old roots into art forms; a material discipline and physical creation motivated by physical beauty and validated by material existence."

Bronze *Torus With Cross-Cap*, carved out of styrofoam and cast solid by "styrofoam perdue," was carved to its final status with tungsten carbide burrs. The gleaming reflective quality of the polished bronze surface completely changes the presence of the sculpture from a hushed monolith of marble to a piece which interacts with the observer, changing color and pattern momentarily according to the motion surrounding it. It is no longer a solid form, but one invaded by chance encounter. The space occupied by the sculpture and that of the viewer have coalesced into one. Light fragments its mirrored sheath, producing abrupt chiaroscuro. It is no longer contained in a single space; rather, it is dynamic and fluid.

The cross-cap of the polished bronze captures the eye and holds it. Dark lines radiate a double wedge from the line of self-intersection and the hole is magically ringed by truncated ripples. In its shimmering surface, Ferguson has mirrored the spirit of mathematics.

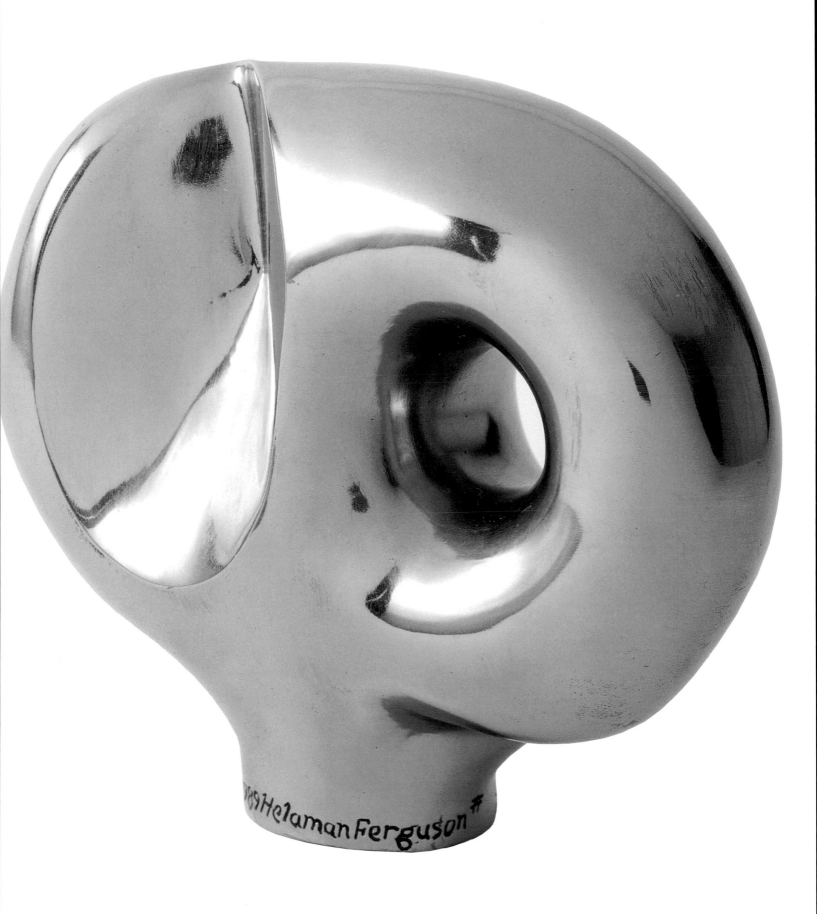

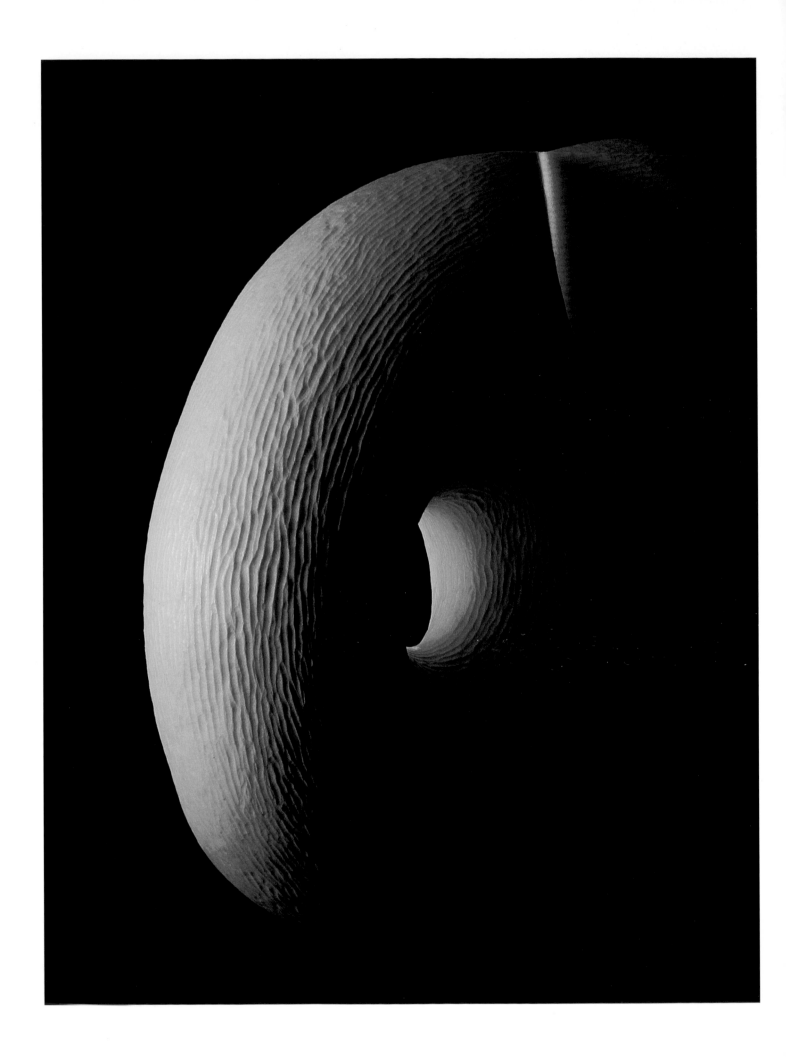

Torus with Cross-Cap and Vector Field

WHITE CARRARA MARBLE, 32" x 36" x 16"

The pristine serenity of *Torus with Cross-Cap and Vector Field* is emphasized by its resolute statement of weighted mass. It is a balanced egg shape with an oval section carved out of the upper mass. The lower half is penetrated by a hole. The cross-cap contains that delicate intersection where the line bisects the elliptical shape. The cross-cap, the thinnest section, is translucent, admitting a slender wedge of light through the marble.

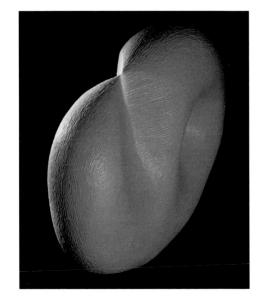

Torus with Cross-Cap and Vector Field bears a resemblance to the Egyptian ankh — the circle being the symbol of life and the line of the cross-cap being the door into the eternities. As the ankh bore its wearer through immortality, the cross-cap invites the viewer inside the eternal stone.

The vector field, the tracks which journey over the surface, articulates the cross-cap. Horizontal lines go through the stone and emerge on the other side. Simultaneously, the hole relates the sculpture to its exterior as a window allows outside light into the interior of a room. Similarly, the cross-cap is a door into the interior of the sculpture, a line of self-intersection.

Torus with Cross-Cap and Vector Field exists in a province of perfection, meditation and pleasure. It is an archetypical work, a symbol of life and immortality, a mathematical ankh containing all the ingredients in the classification theorems for surfaces. Beyond that marvelous presence of peace, harmonic inner relationships successfully express truth beyond the visible world,

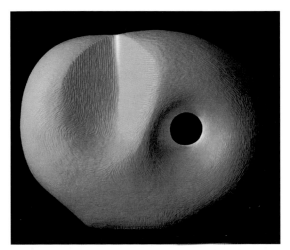

becoming a universal symbol for the unity of reason and beauty that is mathematics.

Figure-Eight Knot Complement II

POLISHED AND HONEYCOMBED CARRARA MARBLE, 34" x 24" x 24"

From the impressionists who attempted to put pure sensation on canvas through the progressive misrepresentation of the world, the viewpoint of the artist has been continually changing. Through the flow of time, the subjective has become more acceptable. In Helaman Ferguson's *Figure-Eight Knot Complement*, the subjective vision of the artist becomes the cocoon from which the substance of mathematical theory can emerge in full-blown beauty. This is the task of making the invisible visible.

The white undulating curves of *Figure-Eight Knot Complement* disguise the hard resistance of the marble. It seems improbable that this beautiful, graceful form had to be chipped out of solid rock. The tactile quality of the polished and honeycomb surfaces invites the touching, rubbing, and caressing, which both closes the distance between viewer and sculptor and increases the perception of its intricate form.

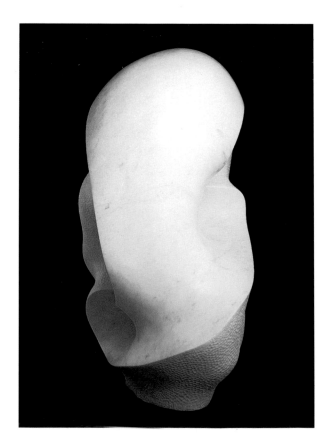

Says Ferguson, "The theme of the figure eight complement is at the very frontier of mathematical research. The complement, the negative space outside the knot, a seemingly amorphous space, has in fact the rigid mathematical structure of a three-dimensional hyperbolic geometry defined by taking lines to be arcs of circles inside but perpendicular to a sphere."

The stone is penetrated by two holes, each of which is traversed twice by the figure eight knot, which is presented in the marble as a ridge or esker. The esker creates a visual pun, the numeral eight on the outline of each hole. Smooth polished marble is on one side of the ridge, a gentle honeycomb texture on the other.

This vision of the artist is ethereal. One sees and feels the harmonious convolutions of the sculpture, but like the wisps of a cloud, they disappear when the viewer tries to reproduce them from memory.

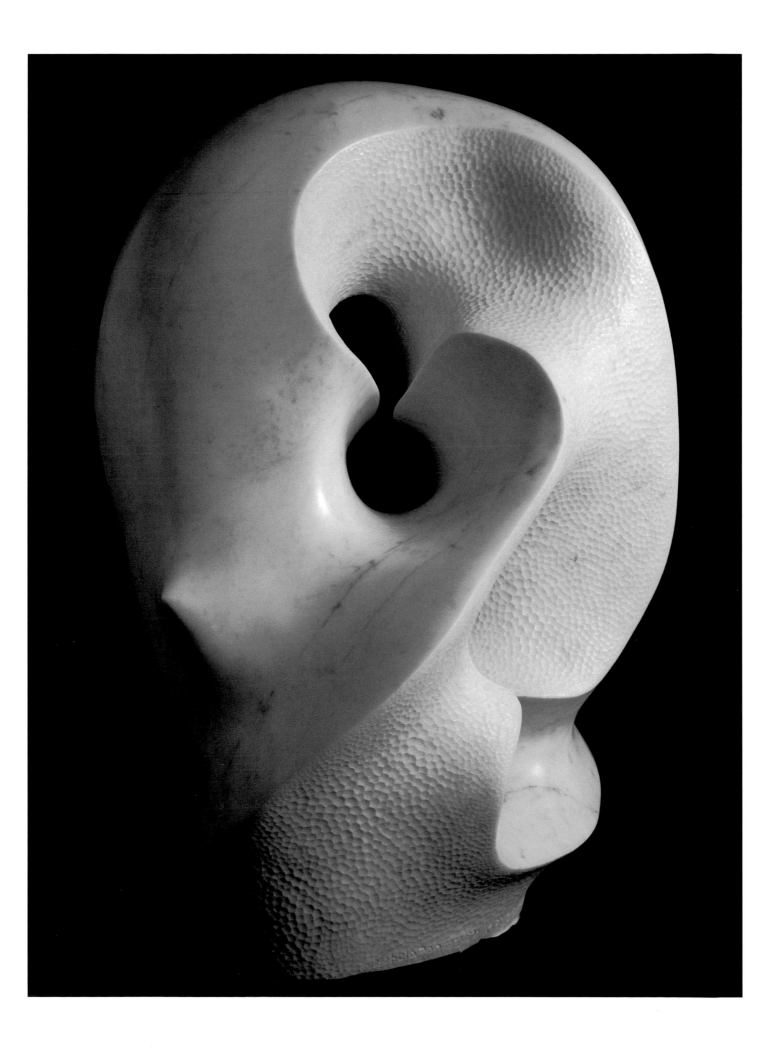

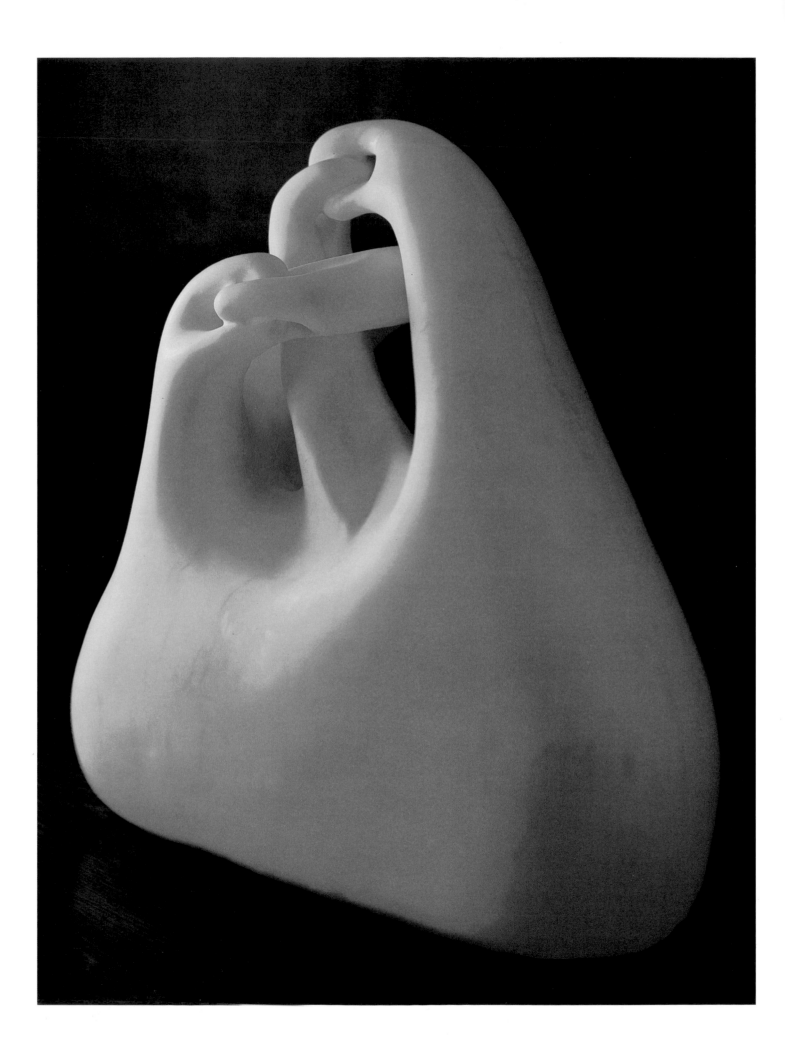

Whaledream II

WHITE CARRARA MARBLE, 24" x 30" x 15"

A monolithic five-hundred fifty pound Alexander horned sphere carved in carrara marble, *Whaledream II* instills that quietude of contemplation one finds in a tranquil Japanese garden. Links merge from a sphere, rising in two pairs to intertwine and join in a graceful ballet.

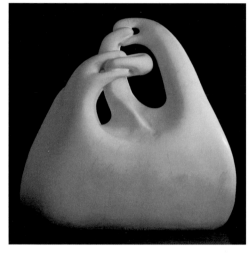

Early in this century, it was discovered that there are two distinct categories of spheres embedded in space: tame and wild. The tameness or wildness of a sphere refers to the complement of the sphere — where the sphere is not. The sphere divides space into two parts: inside and outside. For the tame sphere, or familiar ball, the exterior space simply surrounds it. Punch a hole through a ball and a torus results, for which the negative space is more complex because ambient space is flowing through the hole. But negative space can have more than just holes. The negative space of the wild sphere is infinitely complex. The impact on ambient space is enormous — as divisions occur, they get smaller and smaller like arteries branching into capillaries, until they are so small that they merge with space itself. More than just opening the sphere up, the material and its negative space are fused through its infinitely small replicating bifurcations. In the wild sphere, the limit on the infinitely small replicating bifurcations is a fractal — recognized in our time as even closer to real nature than the familiar sphere itself. This is a revolutionary concept of space and an even more audacious subject for a sculpture.

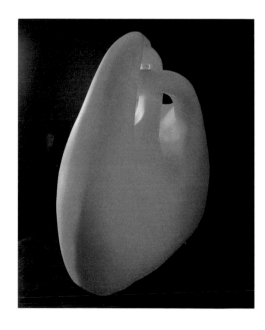

Our perception of space — that construction of intelligence and imagination — has been changed by mathematics since the Greeks. They discovered the principles of perspective, the use of which Plato thought deceptive. The Renaissance saw perspective's apogee, the creation of another reality, a three-dimensional space on two-dimensional canvas. In our lifetimes, space has become an accessible void to be conquered, both outwardly to the stars and inwardly to the fractal. This free unfolding of mathematics is reflected serenely in *Whaledream II*.

The Eight-Fold Way

IMPERIAL DANBY VERMONT MARBLE, VIRGINIA SERPENTINE, 65" x 54" x 54"

The Eight-Fold Way is a stunning installation overlooking the San Francisco Bay from the Mathematical Science Research Institute at Berkeley. Carved out of white Vermont marble, it is a polished tetrahedral form, cupped in a black serpentine column, and centered in a black stone tile circle.

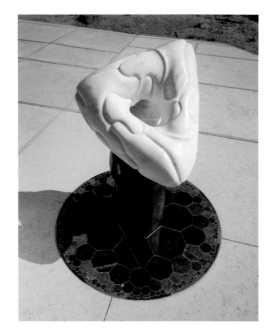

Water jets issuing at 55,000 pounds per square inch were used to cut 232 seven-sided tiles which comprise the circular disk. Such a regular tiling is not possible in Euclidean geometry, but can be accomplished in hyperbolic geometry. A gradual reduction in size of the heptagons as they move outward from the base produces its own illusory sense of perspective. Rising out of this circle of tiles, the seven-sided black column undulates as it nears the footprint. Sinuous ridges and cleft wind over the gleaming white marble and continue through an open center hole which pierces all four triangular sides. Up close, the observer feels an unexpected intimacy with the marble — not surprising because the indented curves and evolving surfaces are in fact, exquisite quotes from the human form.

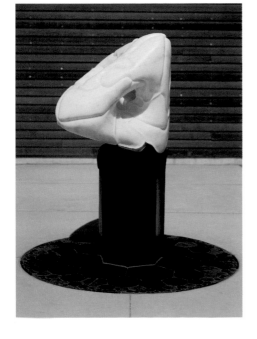

The name *The Eight-Fold Way* arises from the remarkable paths traced by the pattern over the hand-polished marble. Run a finger along any groove or ridge, alternating left and right turns at each corner, and in eight pivots you will return to your starting point. "In examining sculpture," Ferguson says, "one should use all of the body, not just the eyes." Touching and seeing pervasive beauty, one concludes that the creative process that released the abstract ideas encased in this millennia weathered stone combined the analysis of science with the emotion of the artist to produce a symphony of elegant counterpoint — as if Gothic tracery and Alhambra tilings were united in one work.

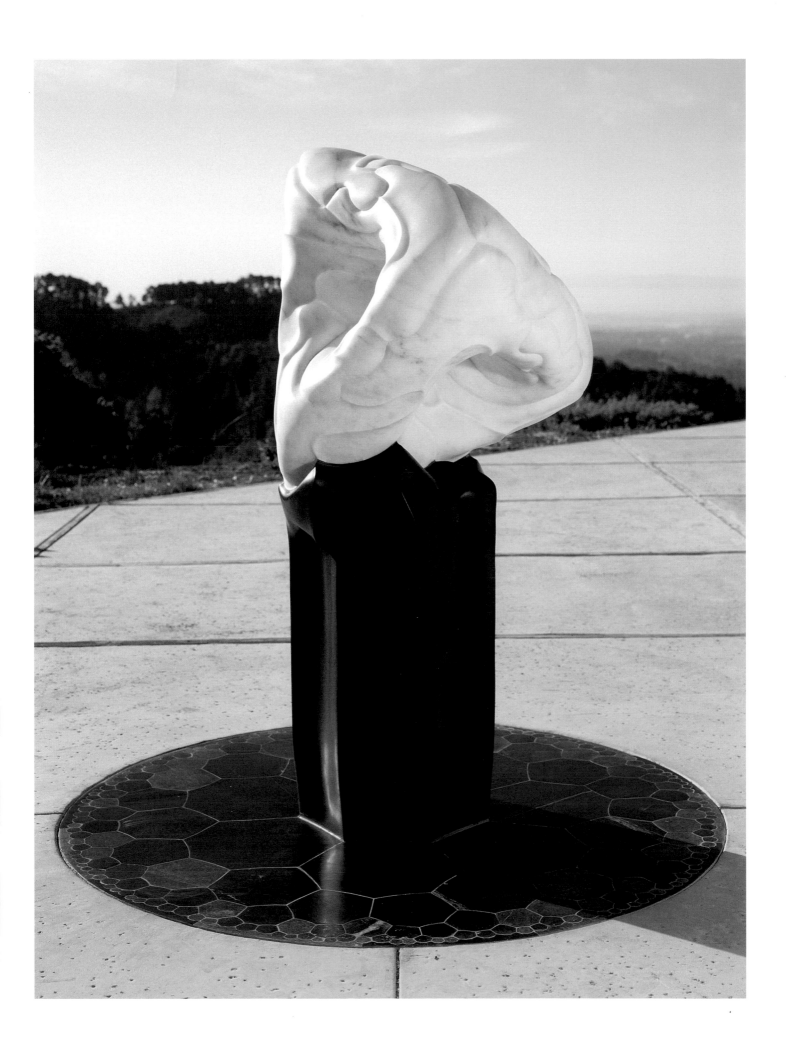

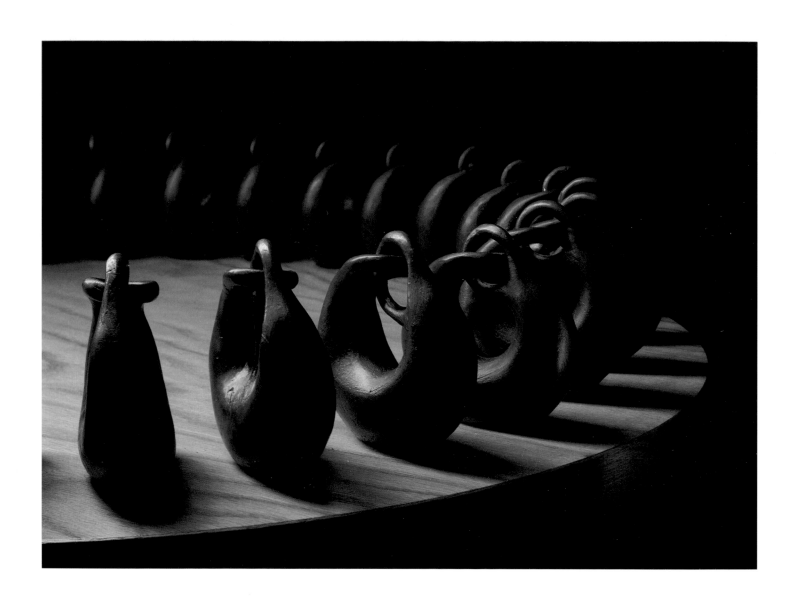

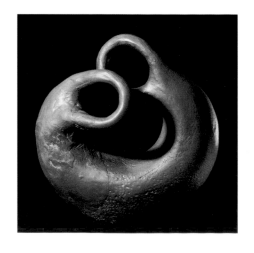 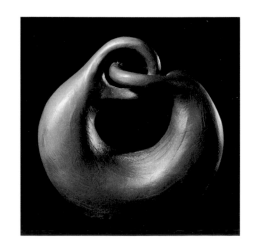

Double Torus Stonehenge: Continuous Linking and Unlinking

28 DOUBLE BRONZE TORII, 6" x 32" x 32"

Representing dynamic movement in sculpture is a challenging problem, particularly if that movement is a continual transformation. A sequence of gestures conveys a powerful image of motion and this is the method the sculptor used to direct the viewer's eye from one point of equilibrium to the next. The twenty-eight satin-finish bronze torii look like Greek amphoras with animated handles spinning on a turnstile. It is a provocative circle.

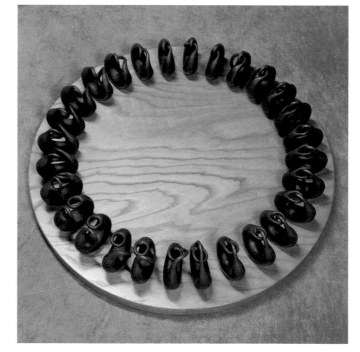

Double Torus Stonehenge is a graduated linking to unlinking of two handles on a double torus, without tearing or breaking. Close your hands, then link the thumb and forefinger of each hand with the other. Now, without opening the fingers try to separate them. The challenge is to find a deformation that unlinks a pair of linked handles.

Double Torus Stonehenge is both a theorem and its proof. From two linked handles on a deformed torus to two unlinked handles, the proof is accomplished by transitions — one step to the next. The torii are designed to be touched so that the proof can be followed tactually as well as visually.

The continual deformations of twenty-eight pieces choreograph a dance in the round, one for each day in the lunar month, referring to our biological rhythms. According to Joseph Campbell, we are children of the stars — our circadian cycles reflect solar systems born of stars. The seven-day week multiplied by four yields roughly a month has its origins in the observations of Babylonian-Sumerian stargazers. Helaman Ferguson's *Double Torus Stonehenge* links and unlinks with small perturbations through twenty-eight stages as the moon waxes and wanes by small changes over the same period.

Umbilic Torus SRC

POLISHED SERPENTINE, 28" x 28" x 10"

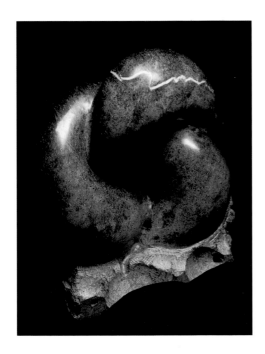

Umbilic Torus SRC has a strong physicality — a reference to the elbow rotation — the curved dent of the brachialis and biceps. This recurring humanity is what makes Ferguson's sculptures approachable and warm rather than the cool, rational expositions one expects from sculpture based in conceptual science. He has dared to couple beauty and vitality. As explained by Herbert Read, "Beauty is no mystery: it can be represented by geometrical formulas, by calculated proportions. But the vital process is intangible, and can be represented only by symbolic forms."

A polished black three-part form rising out of unfinished serpentine, *Umbilic Torus SRC* is the dual of *Umbilic Torus NC*. Together they form a three-dimensional yin and yang.

Out of an aesthetic discovery of a timeless mathematical zone, the theory of group representations, comes an ultimate procreative archetype. *Umbilic Torus SRC* has three intertwining masses, feminine, opulent, nourishing. Its cross section is a rounded, voluptuous, almost convex cardioid form with one inward cusp. *Umbilic Torus NC* is a lean, hard concave form. Its cross section is a hypocycloid with three razor sharp cusps, an indented triangle the protruding corners of which are knife edges. It is the image of war and the axe. Ferguson believes this to be one of the most incredible convergencies of duality in abstract mathematics and ubiquitous human sexual stereotypes. These are sculptural forms fully conscious of the achievements of creative mind over physical matter.

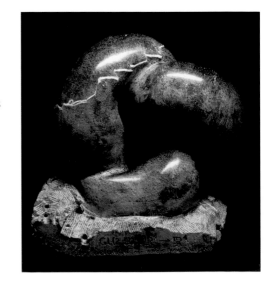

Ferguson's art is demanding and complex; while it demands much of the viewer, it demands more of the artist. Carved in primordial stone it reminds us not only of man's intellectual triumphs, but his frailty against the immensity of time.

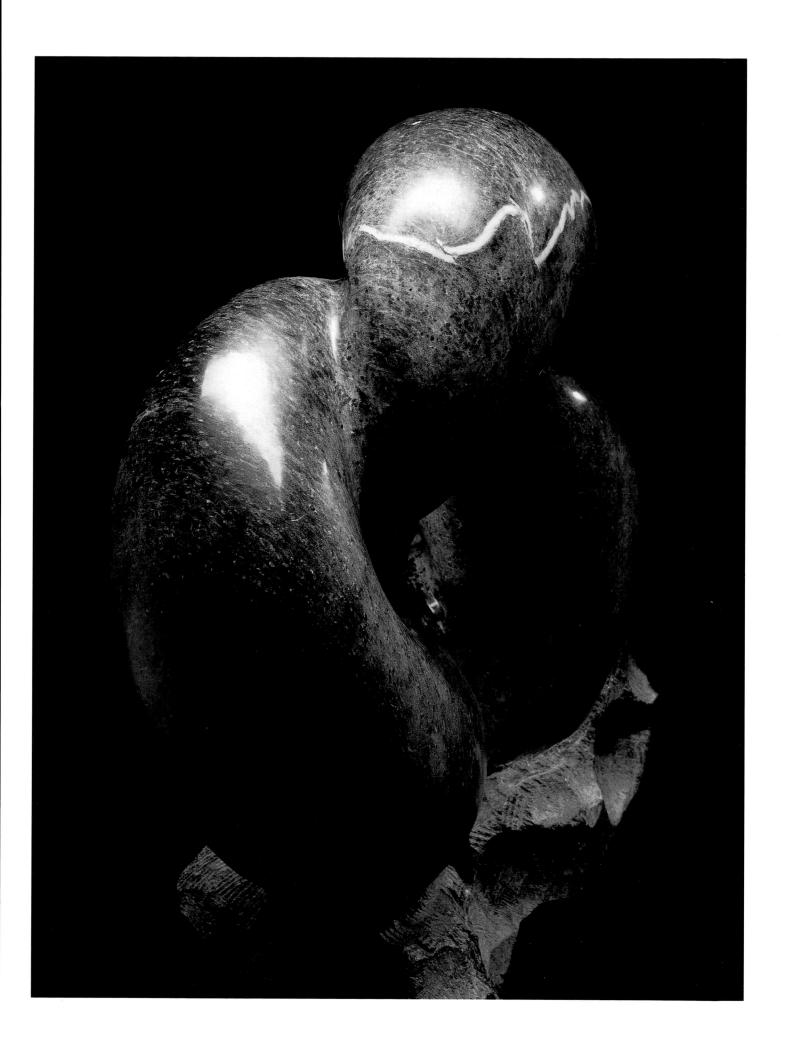

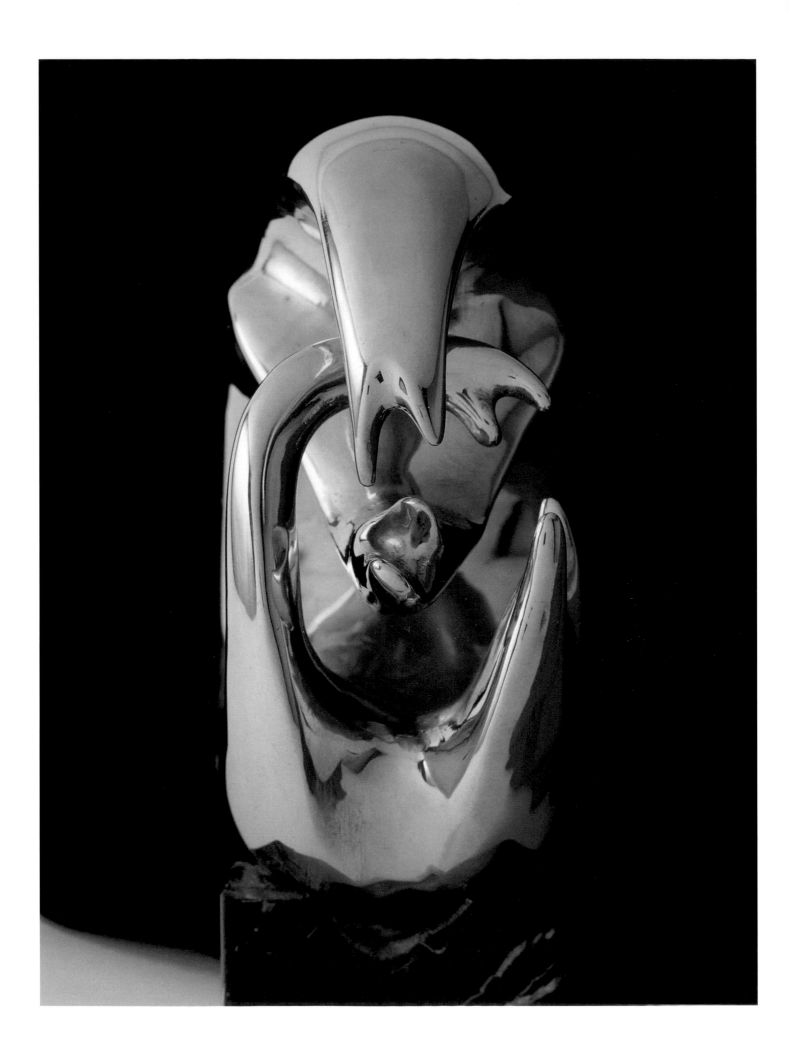

28

Incised Torus Wild Sphere

POLISHED SILICON BRONZE, 8" x 8" x 4"

Incised Torus Wild Sphere has two incarnations. It was first carved directly out of Albemarle serpentine in a way which expressed the infinite construction. After carving a stone sphere, Ferguson penetrated it, creating the hole or "handle" that made it a torus. Double holes were followed by quadruple holes and the delicate stone forms which became branches appeared. Subtract the right things from a torus and a wild sphere emerges, articulating the space inside a torus.

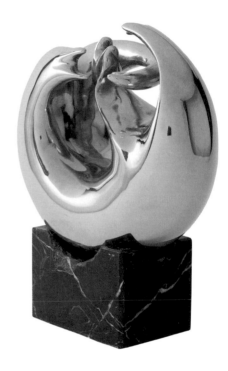

After carving, the direct stone carving was cast in polished bronze. The viewer sees an interrupted torus, a ring gone wild which rests on what remains of its tubular bottom. The upper half has bifurcated into four intertwining arms, from which eight fingers spontaneously emerge. Three physical iterations are presented, inviting the observer to envision the next ones. Tenebrious circular waves are highlighted by shining curves that gather ambient light. Combined with reflected movement, light dances and pulsates over the surface rendering its skin insubstantial, transparent. It is dynamic, never still, a flickering bronze flame. The luminous contrast of dark and light emphasizes the sculpture's sylphlike shape.

In Ferguson's wild sphere, the material is bifurcated into smaller and smaller branches, until they become one with its exterior space, pushing the physical limit to the fractal nature of empty mathematical space. The successive iterations of polishing the bronze, using ever finer grits, reflects an infinite counterpoint to the superdivisibility of the wild sphere. *Incised Torus Wild Sphere* opens a Pandora's box of mathematical furies which insist on artistic expression.

$$A_j \left(\alpha \chi + \beta y \right)^3$$

Thurston's Hyperbolic Knotted Wye II

CARRARA MARBLE, 65" x 32" x 30"

Monumental in aspect, the three ophidian limbs of white carrara marble writhe and twist into a massive knot, emerging from the clawed rock as if freed by an untamed animal. The translucent carrara marble absorbs light so that its uniform dimpled scales are subdued by the intertwined forms.

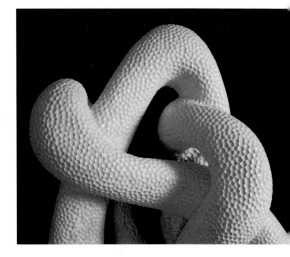

In Greek mythology, Laocoon and his sons were strangled by sea-snakes sent by Poseidon because Laocoon had warned his compatriots about the Trojan horse. *Thurston's Hyperbolic Knotted Wye II* makes allusion to the articulation of arms, legs, and serpents of Laocoonian death throws.

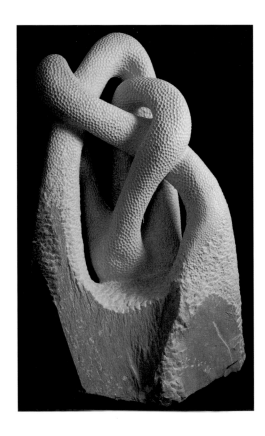

The idea that inspired this piece was brilliantly fathered by William Thurston. Thurston's wonderful idea is that topology has underlying rigid quantitative geometries. By understanding those underlying geometries, one can solve the central problems of topology. The importance of this concept is as profound as man's first learning the abstraction of numbers; realizing that three rocks, three birds, and three apples all had something in common. The numbers one, two, and three are rigid, specific and regular quantitative structures. The integers organize an amorphous collection of things; without them we might count like the Tasmanians, "one, two, plenty." The numbers are an analogy of the rigid geometry underlying topological form.

Art and mathematics are universal languages, not dependent on words. As works of art are part of the process of human thought, mathematics is the refinement of abstraction. Because there is more reality in an image than a word, this sculpture communicates esoteric relations in complex, non-linear ways to our eyes, hands, and other senses. *Thurston's Hyperbolic Knotted Wye II* convolves these two languages, suspending the terror of mathematics in a long moment of marble.

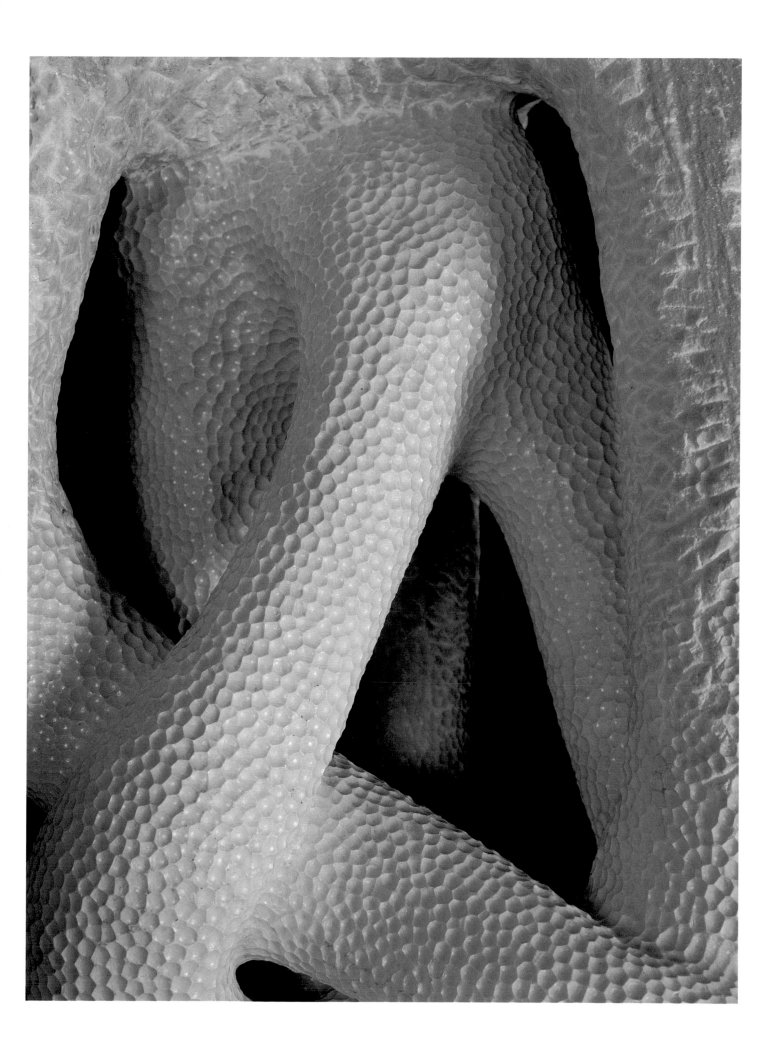

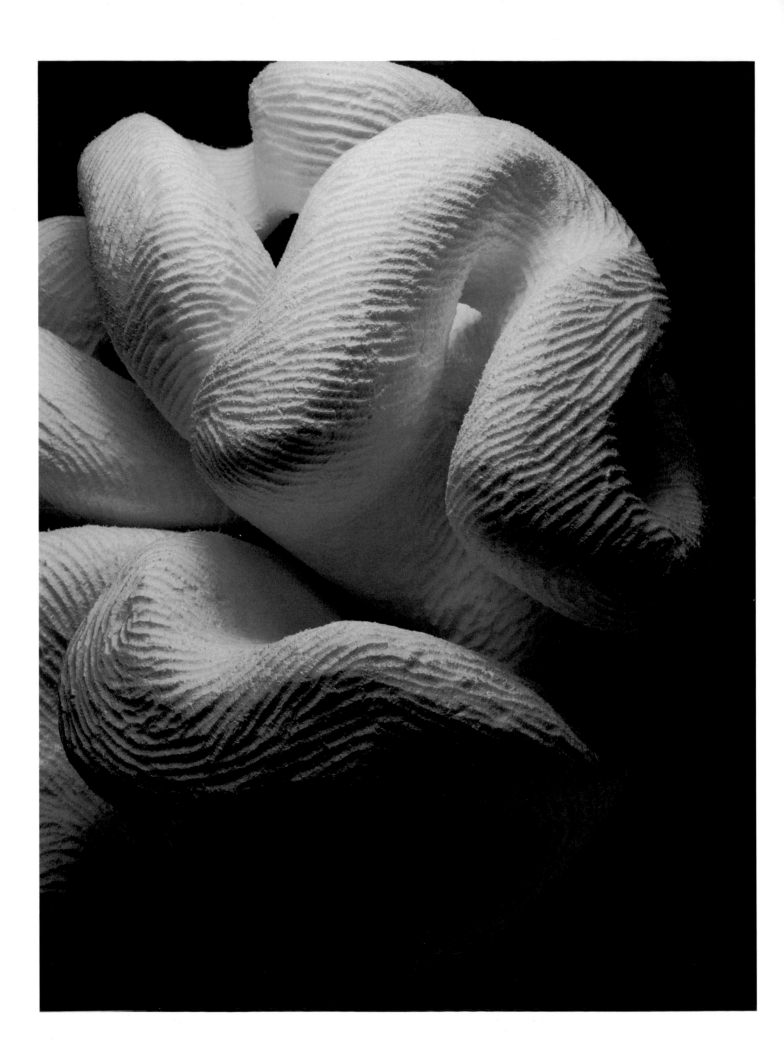

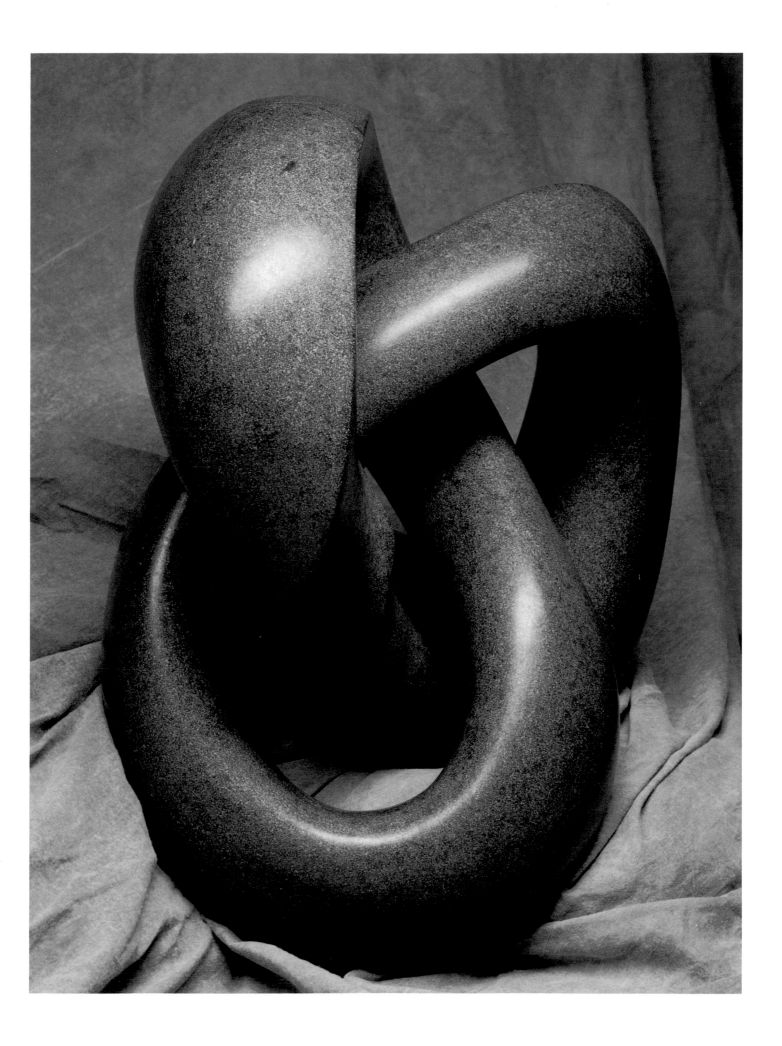

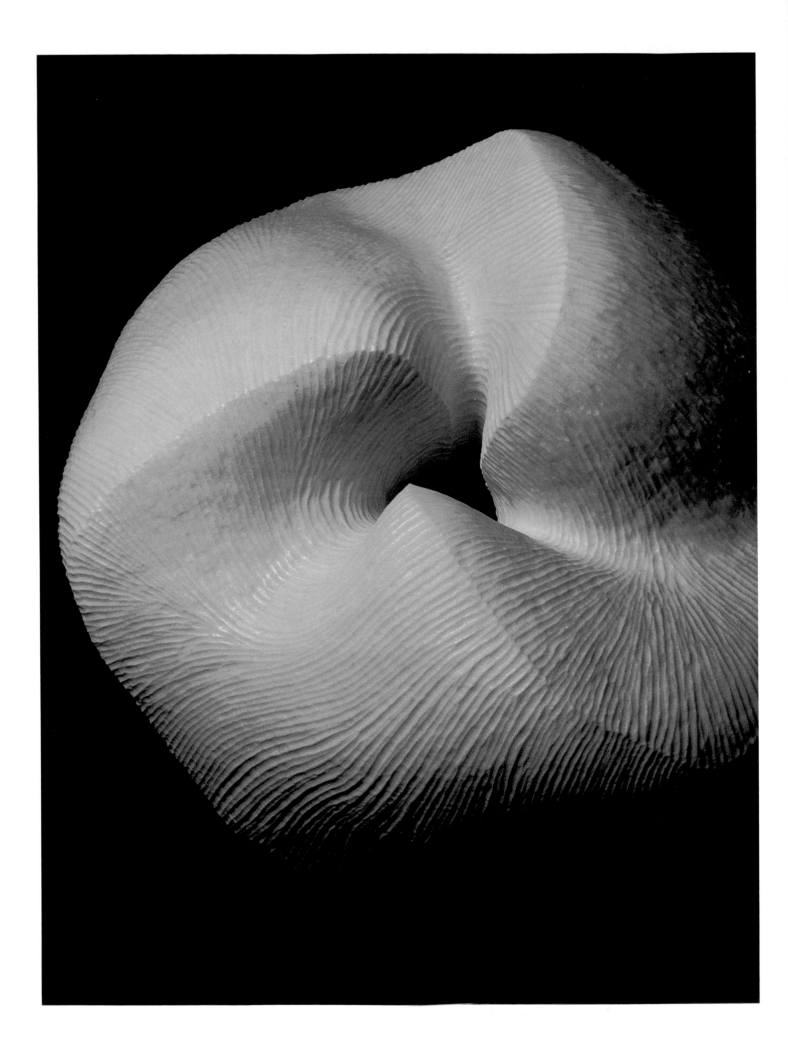

Esker Trefoil Torus

WHITE COLORADO MARBLE, 14" x 26" x 26"

Helaman Ferguson's *Esker Trefoil Torus* is a small ocean of undulating surf — its three waves crest in white Colorado yule statuary around a central whirlpool. As one swell advances, another plunges below it in surging counterpoint. Textured with polished

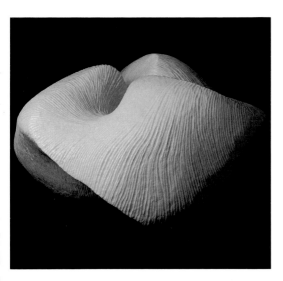

grooves which flow over the rolling curves reflecting the light in sheaves, the sculpture is a pure structure of great intricacy and sophistication. The moment when the billow peaks, it is fixed in time, its tense energy imprisoned in stone. By contrasting that tension with the sensuous fluid form of curves, *Esker Trefoil Torus* captures the excitement of dynamic movement.

Like a glacier scouring rocks, sculptors use exfoliation as a principle process of subtractive carving. The grooves, cut by high speed rotating carbide tungsten balls leave a polished trail that describes a vector field — a system of directions on the surface. The vectors, or polished grooves articulate certain directions until they terminate at the esker — a single closed curve forming a core for a trefoil knot.

Helaman Ferguson enjoys working with stone, hundreds of millions of years old, compatible with the timeless entailments of mathematical thought. The esker curve can be followed twice the long way and thrice the short way around the torus. This one-dimensional curve is itself a trefoil space knot, one of two possible overhand knots with ends joined. The corresponding curves on the Umbilic Tori or on a Mobius strip are not knotted. This stone wave ripples into a gravity defying crest following this knotted space curve. Overlaying the torus amplified by the vector fields, the esker trefoil conveys the romance of an undulating surf, pulsating over the rocks of mathematics.

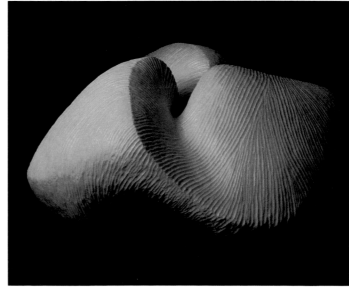

$$\begin{pmatrix} \alpha x + \beta y \\ \gamma x + \delta y \end{pmatrix}$$

Wild Ball, Wild Tree

SILICON BRONZE, 7" x 7" x 7"; SILICON BRONZE, 10" x 9" x 5"

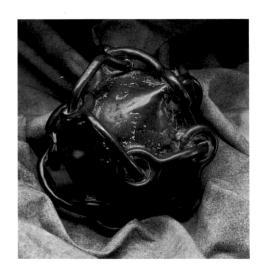

There are two embargoes on humanity which haven't been over-come: dimension and infinity. Though bound by dimension, the construction of *Wild Ball* and *Wild Tree* alludes to infinity. In our material environment, infinity cannot be observed. Even grains of sand are finite because Earth itself is finite. Finiteness seems to be a condition of mortality.

Wild Ball and *Wild Tree* begins with a ball that extrudes twelve feelers. Each of these feelers has a hole and grows through the handle provided by its neighbors. In the next stage, a segment is deleted from each handle which metamorphoses into a tree with twelve linking subtrees. This conception iterates ad infinitum.

There is an earthy solidity communicated by these two solid bronze pieces. They are growing, but weighty, bound to a terres-trial sphere. The ball, like a blastula, has begun to deform, to stretch into the torus which generates the tree. Standing in an array of wild, interconnecting feelers, the tree reaches into the viewer's space with an exuberance that might be born of having success-fully won its battle with gravity as well as delight in the sheer thrill of life. Together they assert the essential dignity and worth of man and his capacity to achieve self-realization through the use of reason and insightful imagination.

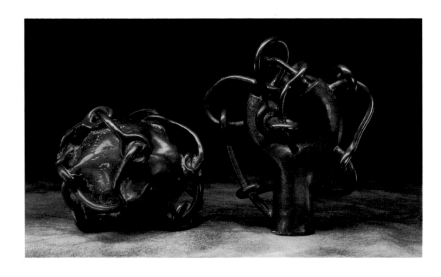

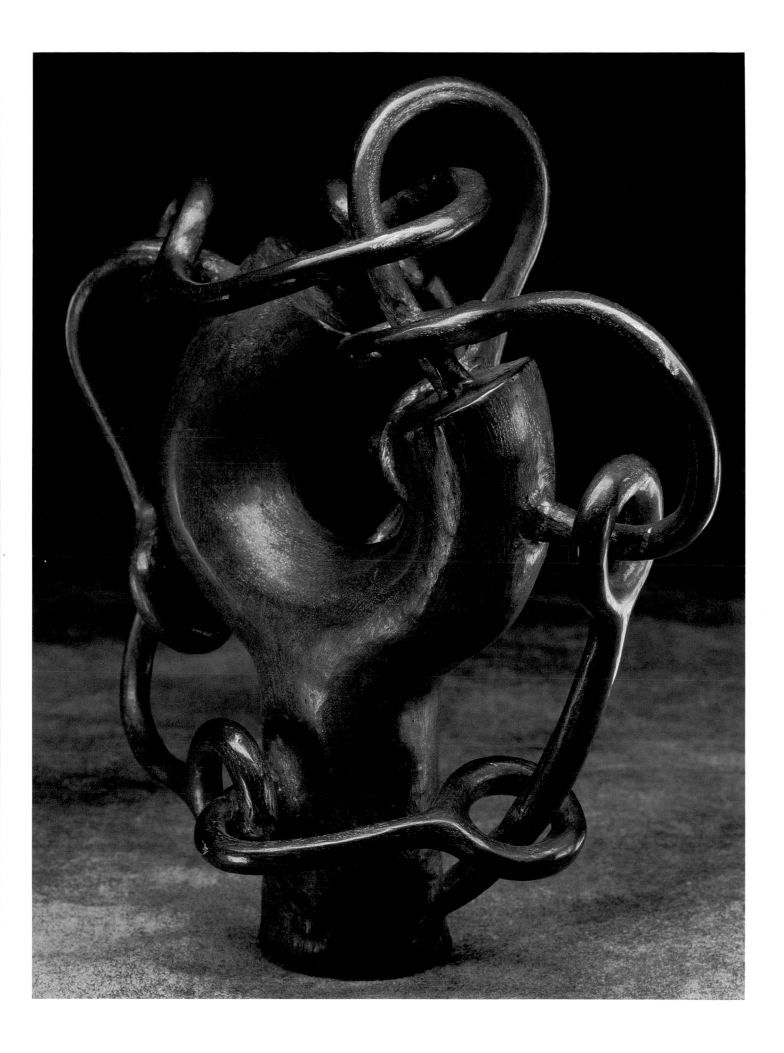

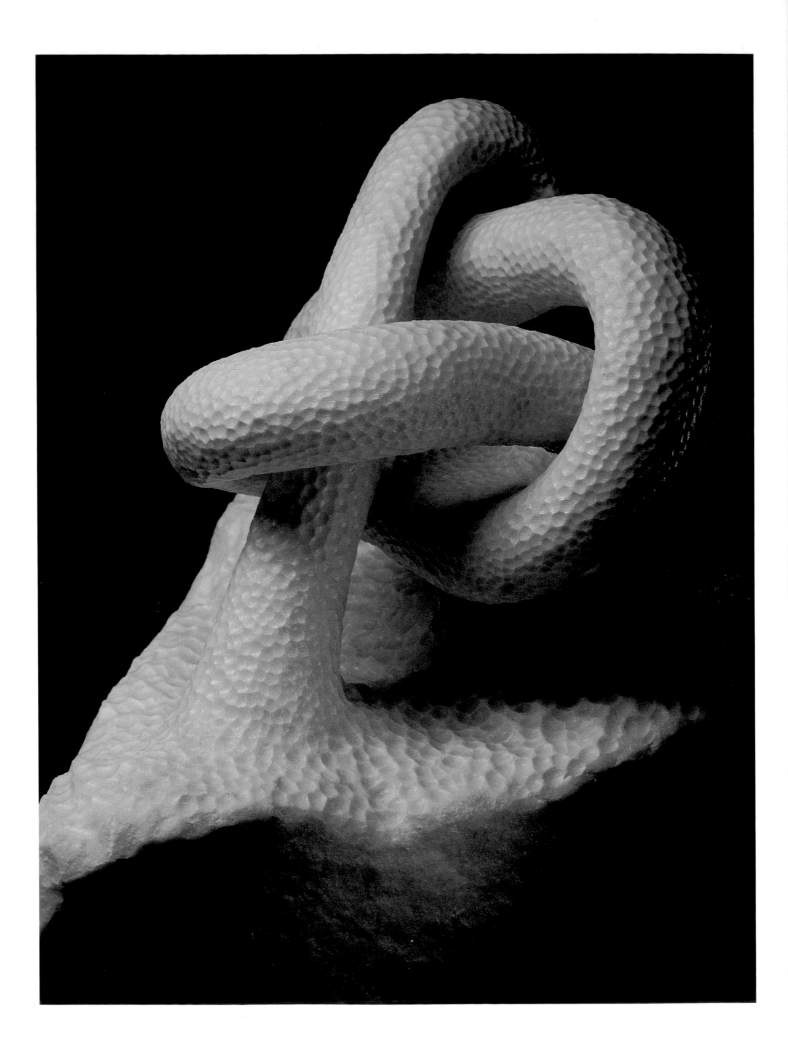

Thurston's Hyperbolic Knotted Wye I

WHITE CARRARA MARBLE, 13" x 17" x 13"

No single viewpoint or central focus is preferred to see this delicate knotted network in space; rather, it can be appreciated from all possible vantages, each one different from the last. As Umberto Boccioni would have preferred, the figure is open, has no finite

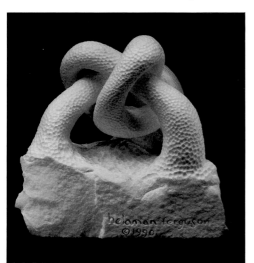

ends, but "intersects with infinite sympathetic harmonies." A knot covered with tiny spherical indentations that look as if they were made by raindrops issues from pristine white carrara marble into a vibrant sea. Above the highest rainsoaked swell, three loops merge. Shadows delineate curves which sinuously vary in size and shape. The only straight lines occur in the triangular base to oppose the loops' continuous curvature.

Directly carved out of a single piece of carrara marble, the knotted network stands on three solid legs. The loops of the interlace are deceptively long and produce an unexpected effect: *Thurston's Hyperbolic Knotted Wye I* rings like a crystal bell when rapped. Most apparent to the viewer is the profile of a trefoil knot, which is undergirded by an exotic hyperbolic structure, the fruit of a millennium of mathematics.

A geodesic is the shortest distance between two points in a given geometry. Years ago, William Thurston discovered the mathematical antecedent of this sculpture as the simplest hyperbolic three manifold with a totally geodesic boundary. Every mathematical creation stands on the shoulders of centuries of prior discovery. Helaman Ferguson celebrates and commemorates Thurston's theorem by adding a physical and unique reality to the topological continents of a collective mathematical imagination.

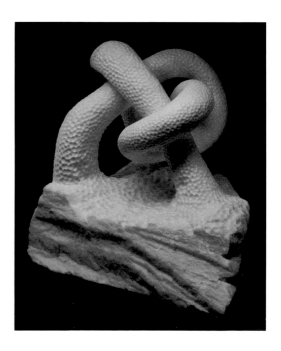

Figure Eight Knot Complement I

KODACHROME FLATS ALABASTER AND SILICON BRONZE, 6" x 4" x 4"

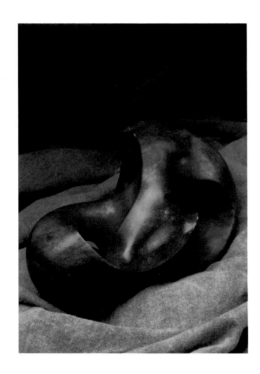

Like a small bird, the red alabaster form is friendly, easily cradled in both hands while curious fingers explore its intricate curves and hollows. The back side, completely pierced by a single hole, changes suddenly from one to two holes as the piece turns a mere twenty degrees. And those holes and hollows are delineated by a sharp cusp, the esker, which traces in and around the indentations and voids in such an intricate design that it is difficult to recall once the piece is out of hand. The hollows and voids set up a rhythmic interchange with the elegant curves which one follows around and through the piece again and again with a sense of wonderment akin to that of holding a mathematical puzzle, perhaps like a Rubik's cube but without the knowledge that it will eventually be solved and discarded. Fingers become familiar with its tactile satisfactions, but it always intrigues the mind.

Figure Eight Knot Complement I is a double torus with two surfaces — each with the shared boundary of a figure eight knot. The two surfaces, polished and satin, are bounded by the figure eight knot raised esker curve which follows a path into and out of the two holes without once crossing itself.

This precursor of the Mount Holyoke piece, *Figure Eight Knot Complement II,* was originally carved in red alabaster from Kodachrome Flats near the Grand Canyon. A silicone rubber mold was taken from the carving and subsequent casting yielded the highly refined bronze version. Its reflective qualities set up an interaction with its environment which is dynamic and fluid as each fleeting movement, each color becomes part of its eternal dance. Both interpretations incorporate a mystery of form which defies capture.

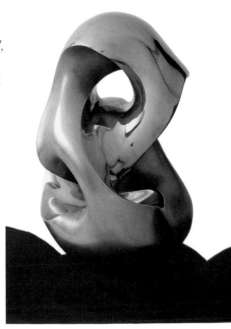

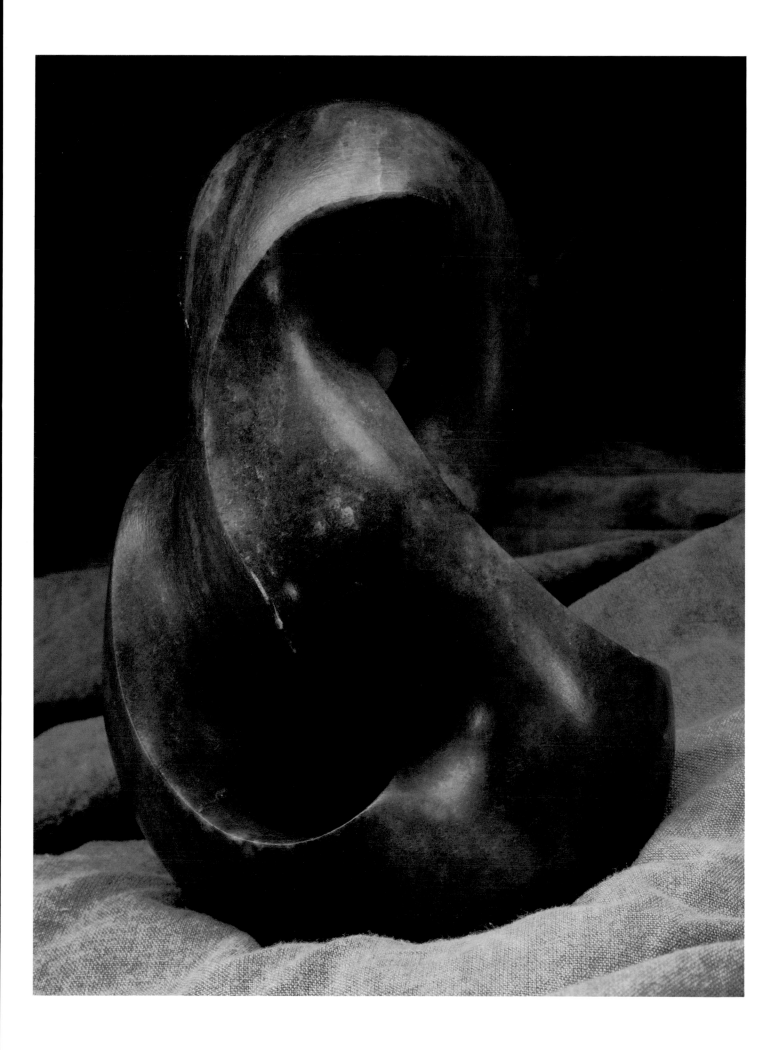

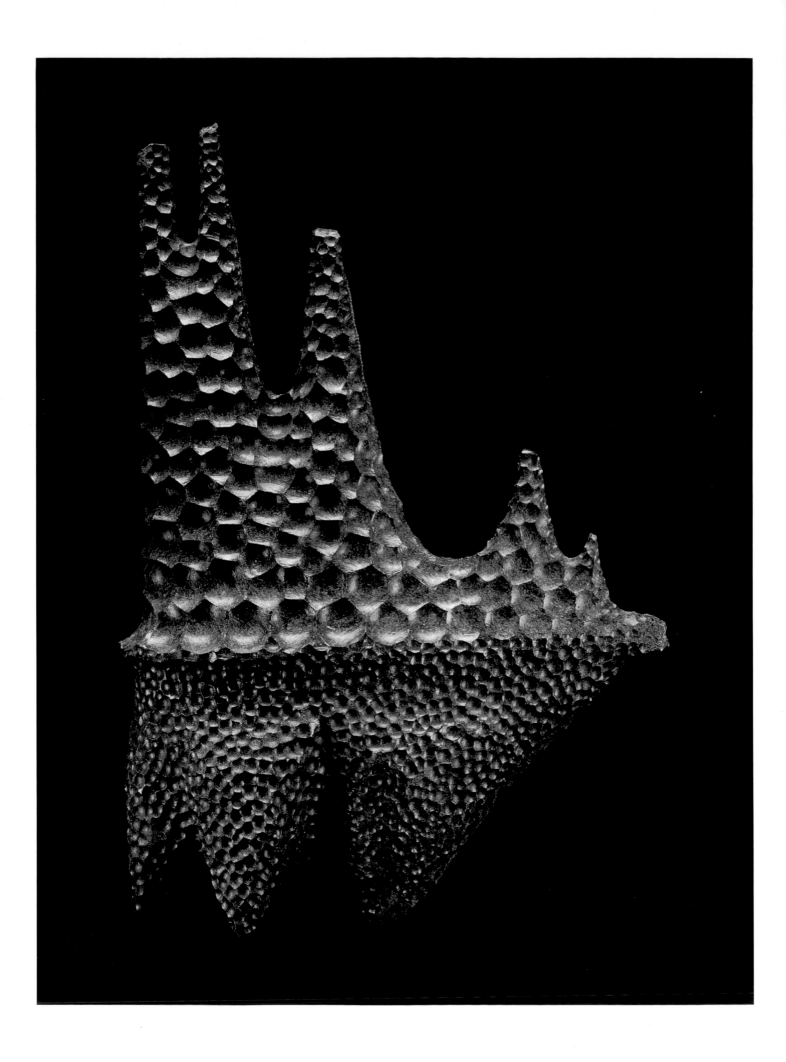

Igusa Conjecture

Albemarle Serpentine, 8" x 7" x 4"

Theorems are created or discovered, but before they are proven, rationally organized, demonstrated and properly stated trophies of the mind, they live vibrantly as conjectures, teetering precariously on the ridge between true and false, proven and unproven, provable and unprovable.

As navigation determines the course of a sea worthy vessel, long standing conjectures have an important impact on the direction of mathematics. Jun-Ichi Igusa's conjecture relates two constructions long considered to be very different. This sculpture, as the conjecture, is divided between poles and eigenvalues. The occurrence of top and bottom graph points enunciates the conjecture of Igusa. A masted ship with many rudders, it sails a true course of unrealized implications.

The sculpture is approximately triangular in shape in two ways: if the stern of the ship is the apex, a vaguely triangular form can be overlaid from that point to the base. As one moves away from the prow along the esker which bisects top from bottom, volume increases with the width, providing a second triangle. The prow is thrust forward, racing eagerly toward the future. There is a sense of anticipation and excited animal energy, as though a friendly fire-breathing dragon inspirited the vessel — the likeness of its snout carved into the overhanging prow, masts held aloft by its dorsal spikes and the hold of the ship morphing into its legs. Along its back the scales are larger as protective armor, catching the light in a hundred gleaming points as a thousand tiny jewels shine from its legs and unprotected underbelly.

Picasso said he did not search for new forms; he found them. Helaman Ferguson finds the theoretical spirits of new forms inhabiting his mind and embodies their essence.

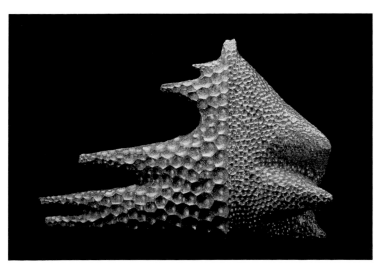

Figure Eight Complement III

WHITE CARRARA MARBLE, 14" x 11" x 7"

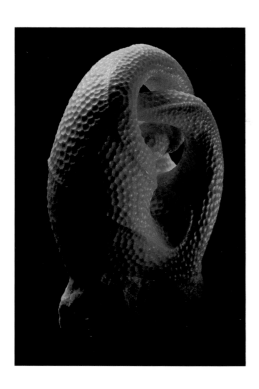

Figure Eight Complement III is a linked double torus, its two handles intertwined in an eternal embrace. A figure eight knot, superimposed on the double torus as an esker curve, encircles the handles but bounds only one surface. Swan-like handles perform a delicate white pas de deux as the linking thrusts through itself.

On this torus, eskers guide the eye upward by repeating the curves of the arcs, forming a figure-eight knot as they traverse the surface of the sculpture. An exquisite intertwining of two graceful forms carved from glistening white carrara marble, *Figure Eight Complement III* is stippled with hexagons which are smaller as they approach the crest of the double torus and larger as they descend. Leonardo da Vinci said, "It is by its surface that the body of any visible thing is represented." The surface of *Figure Eight Complement III* represents the body of a mathematical idea.

Carving stone always entails the risk that an unknown flaw exists which will split the marble in an unwanted way, ruining it and the work which has gone before. The first penetration is crucial to determine its integrity. As Henry Moore quipped, "The first hole through a stone is a revelation." The hole admits light through the solid mass, establishing a counterpoint of volume and void, a rhythm which involves exterior space as an integral part of the sculpture, melding interior and exterior space. In this work, space is involved three ways, through the intertwining holes, the hyperbolic stippling, and the figure eight esker.

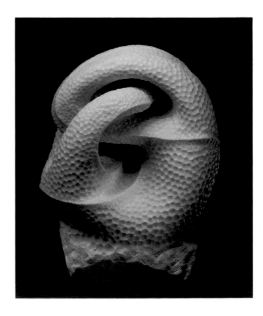

Visual reference to living forms translates into a sense of familiarity. By his use of curves and lines, arches and textures, Ferguson has created a sensuous elegance which incorporates animal suppleness and vigor, expressing a primitive, fundamental and universal effect in pervasively beautiful material.

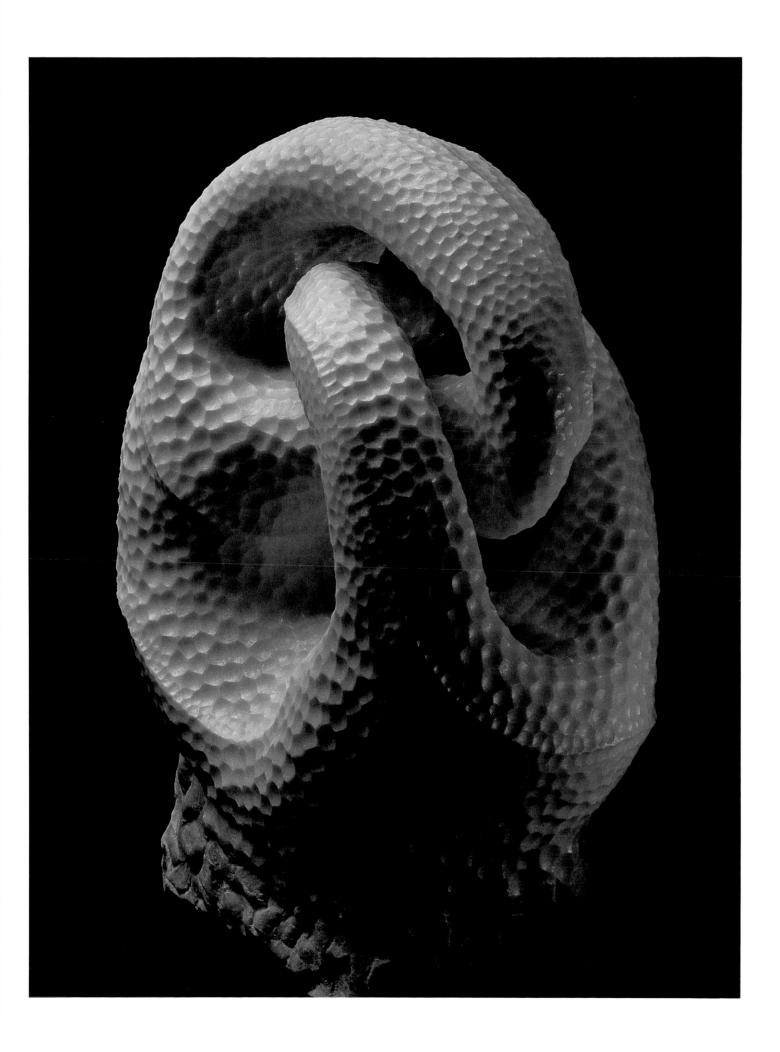

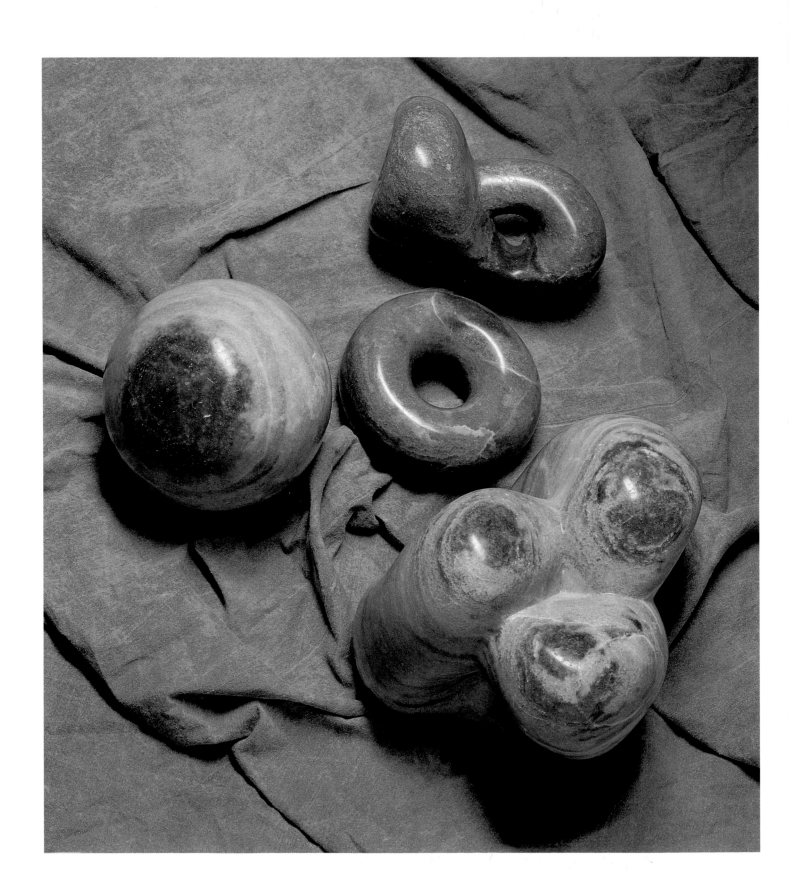

Four Identifications of a Square

KODACHROME FLATS ALABASTER, A GROUP OF FOUR POLISHED CARVINGS
BOY'S SURFACE 9" x 10" x 8", SPHERE 6" x 6" x 6", KLEIN BOTTLE 8" x 6" x 5", TORUS 6" x 6" x 3"

In polished red and green alabaster, this group of two immersions and two embeddings of a square exude a primitive feeling kindred to that which one experiences seeing an ancient South American globe or a flawless quartz crystal ball. In fact, the Colorado River Basin henna and green alabaster forms were carved freehand, which, considering the perfection required for a sphere, is as remarkable as Ferguson's later use of advanced technology.

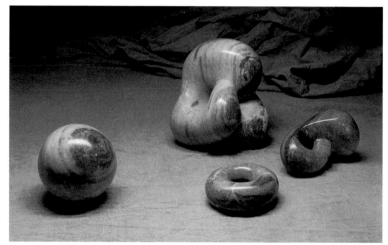

These four figures all have surfaces of a common ancestor — a plain old plane square. Four simple ways to sew up a square are: *Sphere*, sewn like an apple turnover, without twisting; *Torus*, sew opposite sides without twists; *Klein Bottle*, sew opposite sides, one pair plain, one pair twisted; and *Boy's Surface*, sew opposite sides, both pairs twisted. A seamstress would find these instructions pretty laughable. Sew up the sides of a piece of square material? Mathematicians, however, are like lovers — they revel in carrying a simple idea as far as possible. There are infinitely many ways to sew the opposite sides of a square, most involving self-intersections, or cross-caps. Is there a way to sew without self-intersections? Yes! Simply embed in four rather than three spatial dimensions.

Like many of Helaman Ferguson's sculptures, *Four Identifications of a Square* conveys the beautiful notion of surfaces as discrete group quotients — sometimes of the sphere, frequently of the euclidean plane, and other times of the hyperbolic plane — the three possible universal covering spaces of all surfaces.

Jaime Escalante Award

SILICON BRONZE, 8" x 5" x 3"

A real-life hero at East Los Angeles's Garfield High, Jamie Escalante was an unusually dynamic mathematics teacher, who possessed a vision of mathematics as a key to the advancement of his inner-city students. Jamie Escalante's courageous work in teaching calculus was honored in the popular film "Stand and Deliver." These sculptures are awarded to outstanding mathematics teachers in Los Angeles school districts by Arco.

In response to Theseus's vow, "I'll love you forever if you can show me a way to come out of the labyrinth," the princess Ariadne gave Theseus a ball of string, which he unwound as he entered the labyrinth and then followed out of the difficult Cretan maze. Like her, Jamie Escalante has gifted his students with Ariadne's string through their knowledge of mathematics.

The umbilic torus stands on a black marble base, its surface covered with a single Hilbert space-filling curve which has overtones of an ancient maze. Were this curve unraveled like Ariadne's string, it would be over six yards long. The pattern has a dynamic rhythm produced by its unbroken repetitive sweep over the interior and exterior of the torus. Negative space is as captivating as positive space in the fractal curve, as in an M.C. Escher drawing, the eye resonates between two. Attractive warm bronze tones which shine through the translucent umber patina and its palm-sized dimensions invite handling. The circle, which traditionally represents the psyche, celebrates each of these gifted teacher's heroic contributions to its development and the fulfillment of human potential.

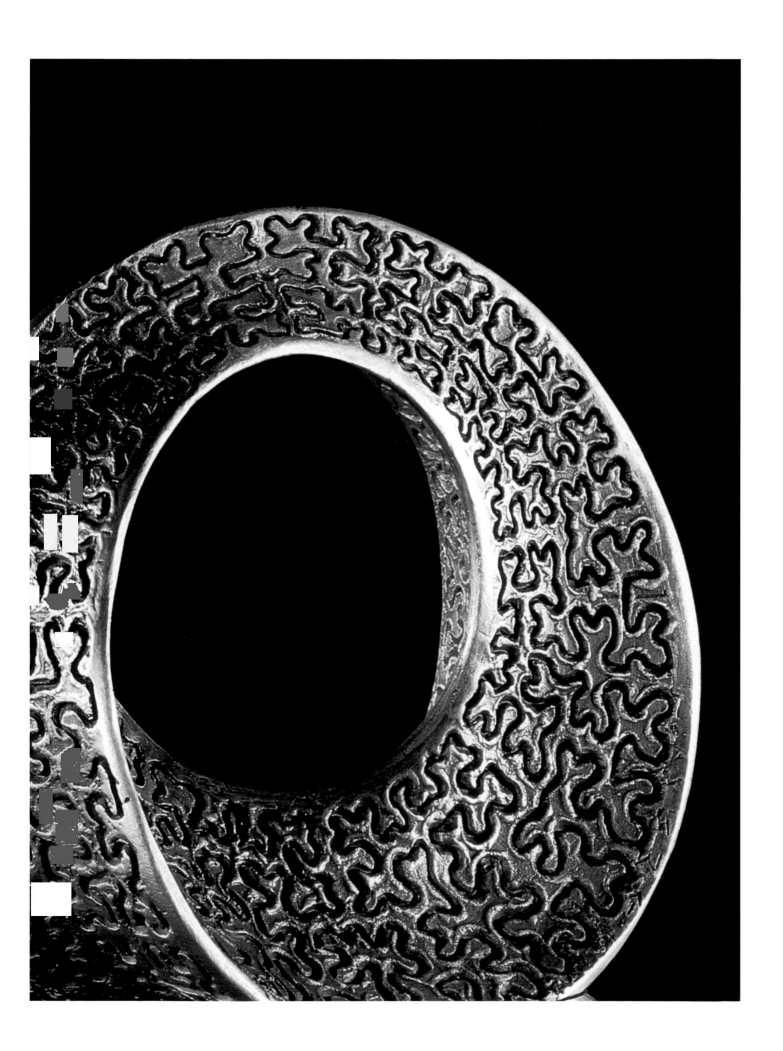

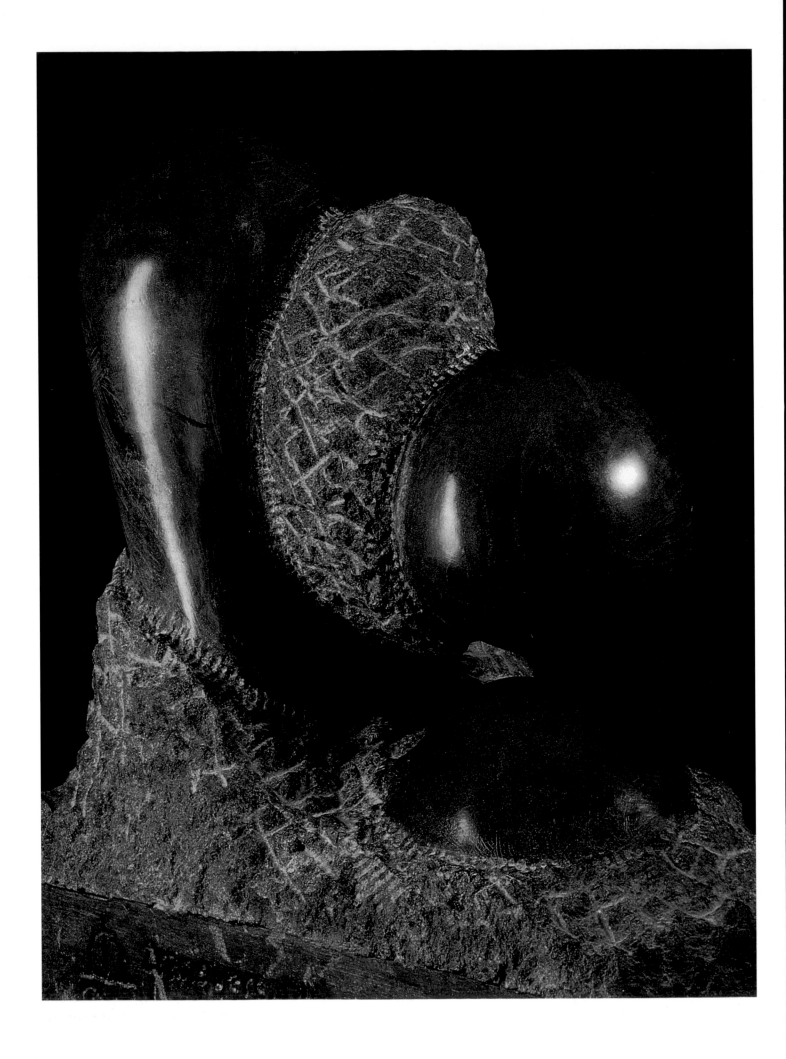

cxy^2

Transversality

ALBEMARLE SERPENTINE, 20" x 20" x 12"

This sculpture has to do with the delicate matter of mathematical stability of smooth mappings. Historically, this matter resisted understanding or proofs until a ridiculously simple idea — *transversality* — clarified the whole business. Two objects in a space are transversal if they don't touch at all or if they interpenetrate.

Transversality has the nuance of primitive Eskimo sculpture. If one can imagine this sculpture as an abstract mother sea lion reaching solicitously for her pup, then her head and body, which are separated by the spontaneously crosshatched furry mane, are transversal because they interpenetrate. She and her pup are also transversal because they are not touching. She is on a diagonal, moving over the volcanic rocks toward the small polished round in a maternal gesture of tenderness. Had she completed the motion, sniffing noses, she and her pup would no longer be transversal.

The hindquarters of the mother seal lion are sculpted into a beautiful naturalistic S-curve, frequently found in classical representations of the human body. Repetitive, violent crosshatching of the mane and the rocks provide a satisfying unity between the reaching form and its base. By incorporating this contrasting treatment of the serpentine, the sculpture is given the impression and color changes of raw rock.

The figure's inclined weight shift, stretching toward the partial sphere below it, creates the illusion of expressive movement, which even in nonmimetic art relates it to a living body image. The enlivened character of *Transversality* warmly celebrates the paradigm shift which accompanies every scientific breakthrough, large or small.

Essential Singularity

Milled Aluminum, 14" x 20" x 10"

Essential Singularity, Ferguson's first piece with computer involvement, is a complicated construction unified by the single statement of the light-responsive anodized aluminum from which it is made. Ferguson has employed perceptually explicit shapes whose only ambiguity is that inherent in the shimmering shapes momentarily caught in its reflection. A pole of diminishing stacked disks rises above a pool of progressively smaller concentric circles in a rectangular base. Repeating one of the sculptor's favorite motifs, ying and yang, the inside of the construction is the pole, the outside is the pool.

The highly polished descending crescents seem to be already filled with water. Tactically experienced, the image of this sculpture is inescapable. On a monumental scale, it might have a psychic effect similar to that of the pyramids or the Eiffel Tower to which it is related by virtue of its mathematical order. Like them, it would be an aggressive symbol of civilization, a victory of aesthetic mind over industrial matter.

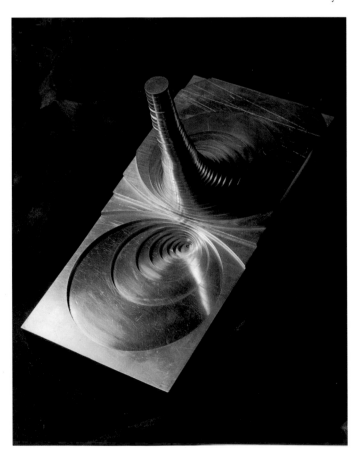

Essential Singularity is based in the theory of functions of a single complex variable, the pole is a mathematical singularity that cannot be algebraically subtracted from its function. The clearly defined form of the vertical axis of the pole rises immediately above the deepest circle of the pool. Looking down from it, one sees a double nesting of circles which all appear to touch at a single point.

Visually activated by motion in the space surrounding it, like a still pond, *Essential Singularity's* repetitive circles have a quieting effect upon the observer. Those round images of infinity combined with the illusion of water evoke a restful solitude as the upward impulse of the stepped projection urges the viewer to loftier visions.

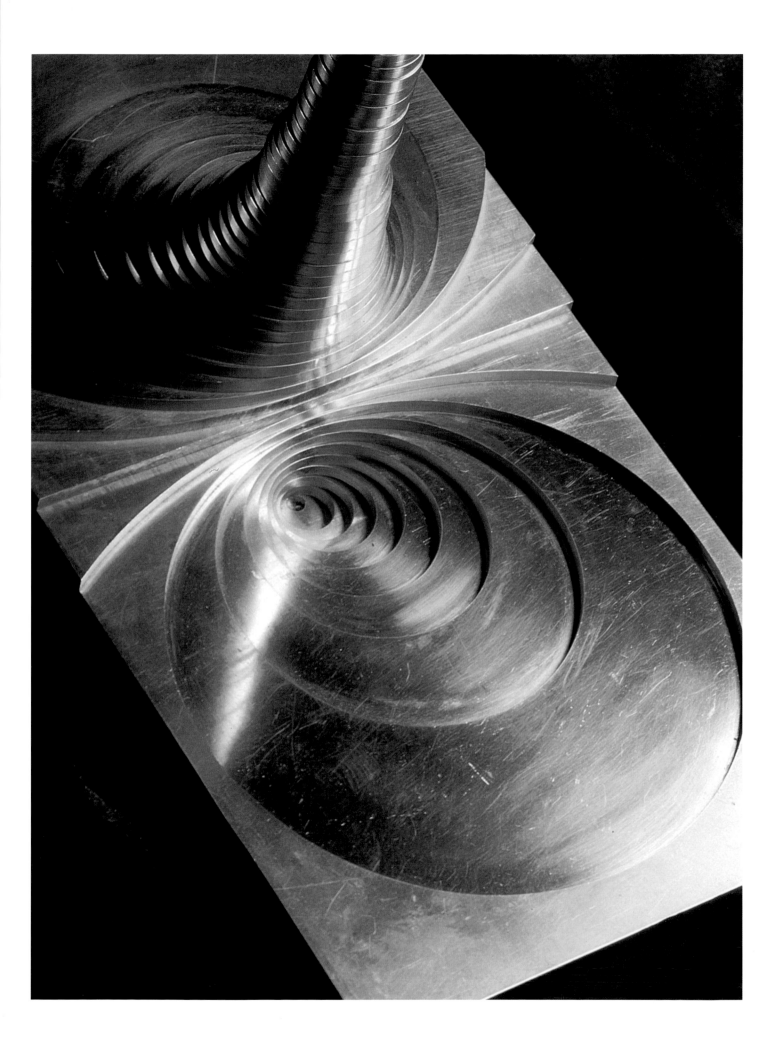

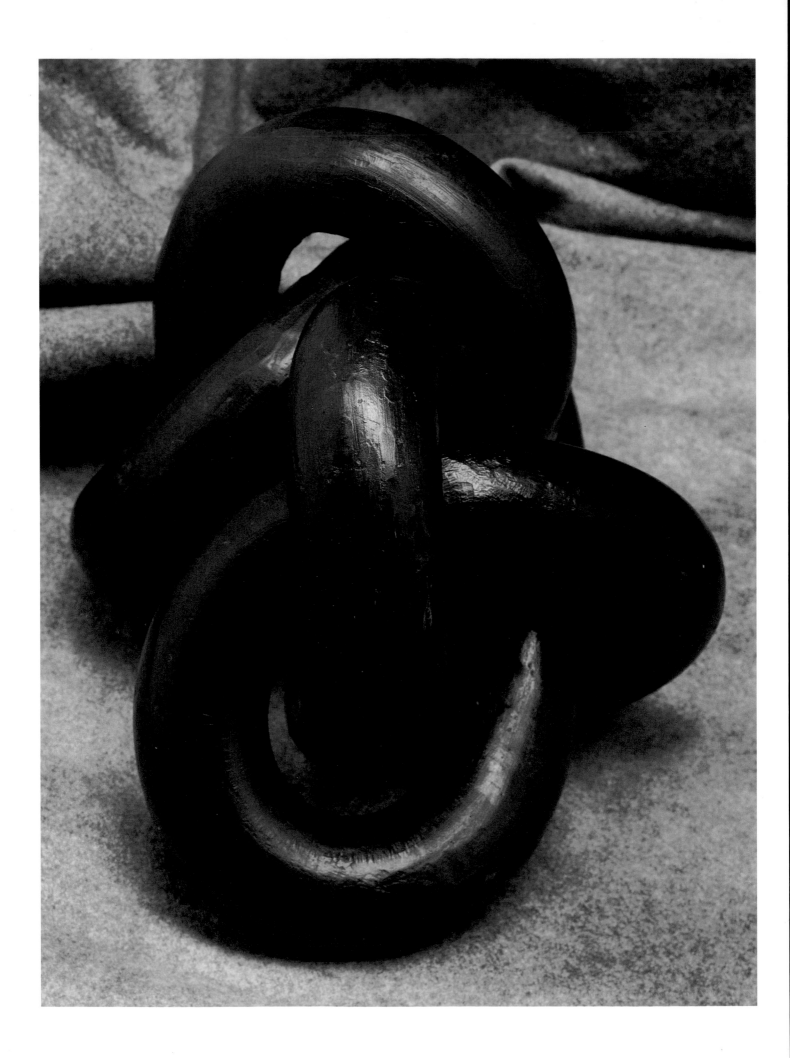

$$(\alpha\chi+\beta y)^{3-j}$$

Three Knots

SILICON BRONZE, 4" x 16" x 16"

The sculpture, *Three Knots*, is a group of four bronzes, mirror images in pairs. The two trefoils cannot be continuously deformed into each other, whereas the two figure-eight knots can.

Alexander the Great didn't play the game by the rules — he cut the Gordian knot with his sword. His reply, to the offended priestesses who had expected him to untie it in the normal way by smooth deformations, was like that of mathematicians, "You didn't say I couldn't do it this way!" Mathematicians frequently shoot the arrow and then draw the bull's eye.

The simplest possible knot, the trefoil, doesn't approach the complexity of the famous Gordian knot, but it resists being smoothly deformed into its mirror image or the figure-eight knot with the same fierce determination. It would have to be sliced like its illustrious forebear and reconnected into its mirror image or the figure-eight knot.

The three knots are solid bronze finished with a satin patina. Larger than hand size, they carry the weight of their significance with balance and grace. Solidity is the first impression conveyed by these sinuous interweavings, but their exterior empty space is even more complex than the interior space created by the loops of the knots passing through themselves and not touching. That space, the knots' complement, is a veritable cornucopia of riches to mathematicians. Enduring and ageless, these knots could have come from any ancient or future society as objects of mystery and ceremony, but there remains this puzzle to the eye: where do the knots begin and end, and where shall the eye come to rest contemplating their intricacies? There is no beginning, nor end. The vision, focused to seek peace, continues to trace the endless cycle of these linear symbols of periodic motion, orbits of planets.

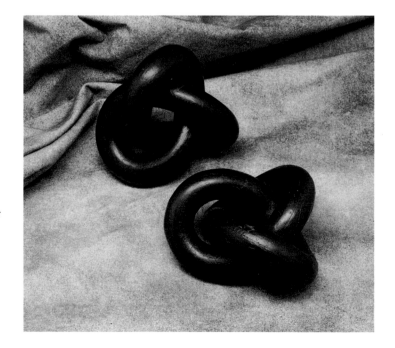

Three Spheres

SILICON BRONZE, 8" x 5" x 3"

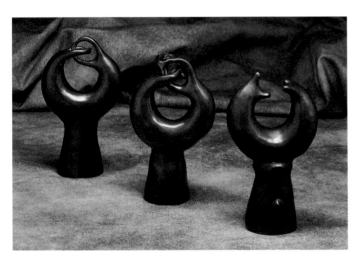

Part of a whole sequence of horned spheres, each sphere in *Three Spheres* is in a different stage of becoming wild, morphing from one bifurcation to the next. The first stage is comprised of three bifurcations of divisions — it is the porpoise stage — an exuberant leap for joy — a mammal bursting out of the water. Next, two branches reach out toward each other and link in an expression of chosen friendship, a voluntary state which is four bifurcations toward the double torus. The last of the three occurs as each link thins, separates, and sprouts a pair of two more branches. The sphere has divided fifteen times to get to this point, its outstretched arms entreating, growing, seeking the warmth of the sun.

The three stages represent an infinity of forms. Each bifurcation doubles the number of branches, which then grow, link, thin, and branch to the next stage.

These bronze figures have the primitive presence and gentle forms of Eskimo art. Their modeling is by the artist's hand, not machined. All have the contours of living things, as though flesh and blood were caught by Midas' touch and turned to unyielding metal. Even the morphing tree has soft, organic lines, all curves, gradually narrowing toward the branches. It is the humanity inherent in their execution which gives the sense of connection with the real world. They incorporate a dimension relatively new to the world of matter becoming so infinitesimal it is indistinguishable from space. But in that they are not the products of unfeeling formulas, cold and withdrawn. Scientists have a magical relationship with the material world — they can transform a mathematical idea into matter as artists transform expressive emotions into material objects. In these creations, the marks of both are left visible to the beholder.

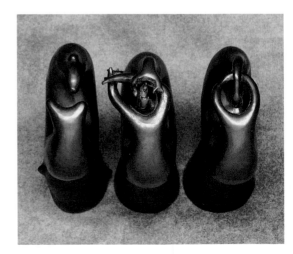

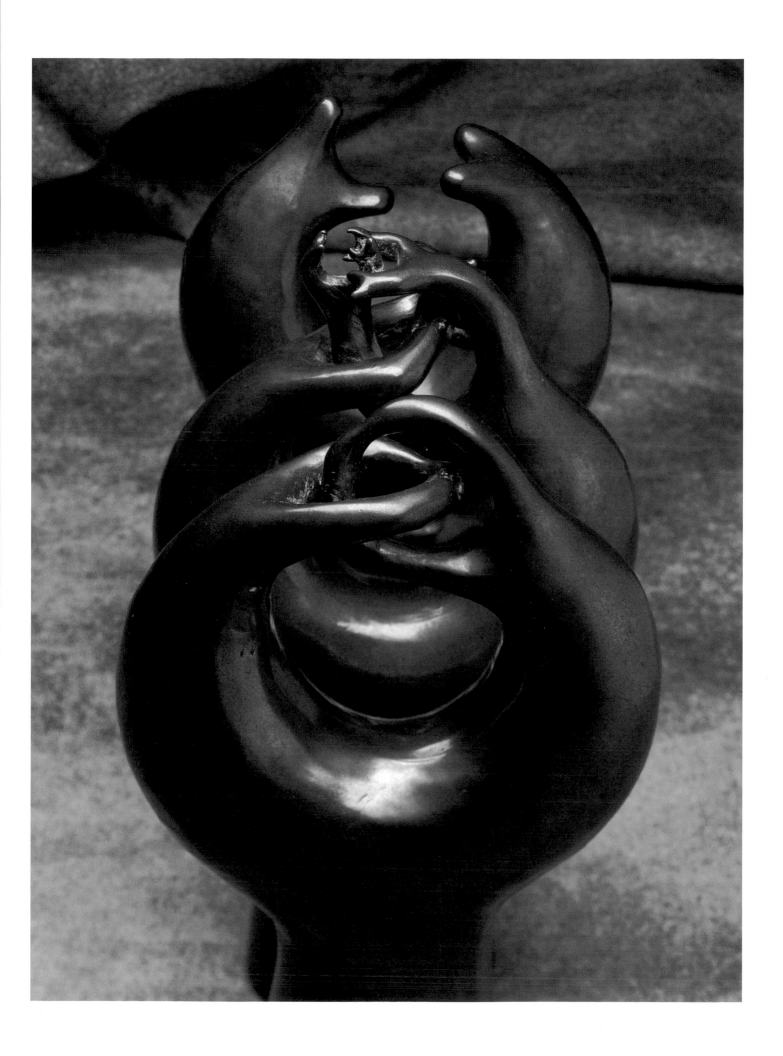

$$\begin{pmatrix} \alpha & \beta \\ \gamma & \delta \end{pmatrix} : \sum_{0 \leq j \leq 3} A_j \chi^{3-j} y$$

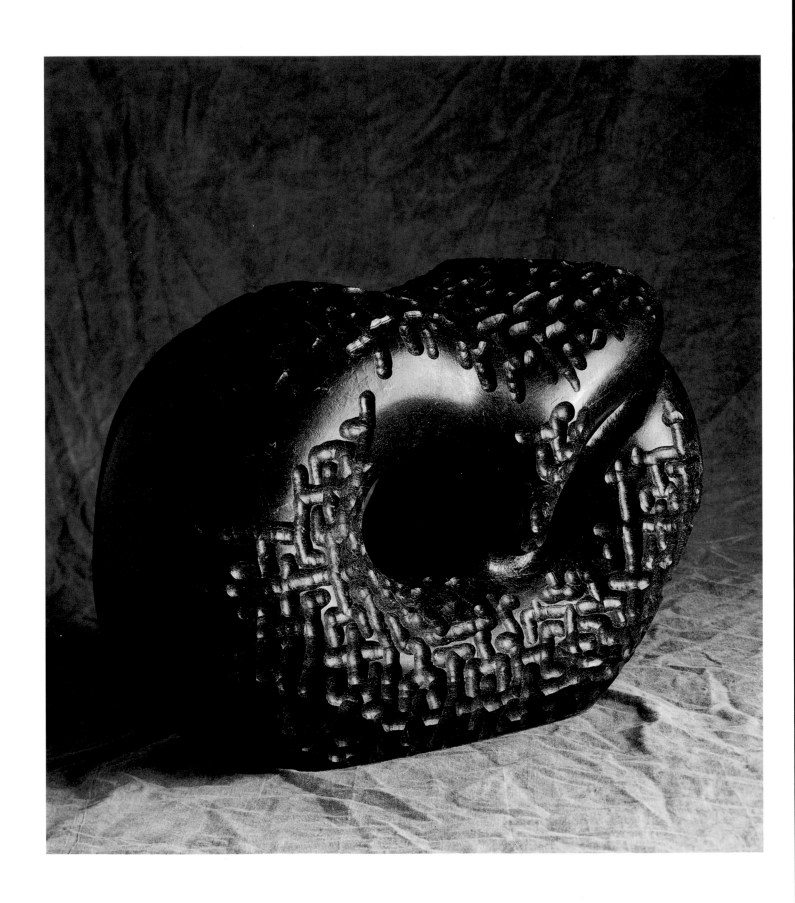

Bivariate Cauchy Kernel

ALBEMARLE SERPENTINE, AVIAN: 12" x 10", REPTILIAN: 8" x 12" x 8"

Two forms, each pieced by a center hole that creates a visual melody between void and mass, constitute *Bivariate Cauchy Kernel*. One is reptilian — ouroboros, the eternally self-destructing and recreating serpent of ancient Egypt and Greece, its tail in its mouth. The other, a more familiar toroidal shape, rises birdlike from its base, head buried beneath its wing.

Two patterns differentiate the forms further. The emblematic ouroboros is partially covered in a scaly surface-filling maze, its linear design exposing more positive space than negative, catching the light like a shower of little arrows. The avian structure is overlaid with a surface-filling curve revealing greater negative space. The gesture of the avian shape is vertical, an upright thrusting as opposed to the more lateral, self-devouring snake. Ouroboros is a classical dualism representing the unity of all things material and spiritual which never disappear, but perpetually change form. Both carvings refer to early terrestrial life forms correspondent with the

age of the albemarle serpentine, an image reinforced by leaving some unpatterned areas polished to a smooth black finish as though exposing the vulnerable abdomen of a creature.

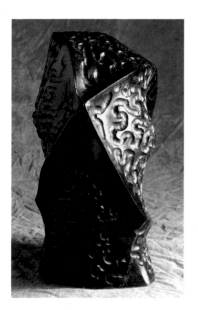

Named after the nineteenth-century mathematician Cauchy, the two tori are dual, a significant theme in mathematics — the inside of each torus is the topological outside of the other. Conceptually, Ferguson has compacted the immense reach of space from one into the interior of the other.

The duality incorporated in this sculptural adventure reconciles several seemingly contrary states. It takes ancient organic lifeforms and combines them with the most purely rational concepts of which mankind is capable, mathematical order, demonstrating the finite and the infinite.

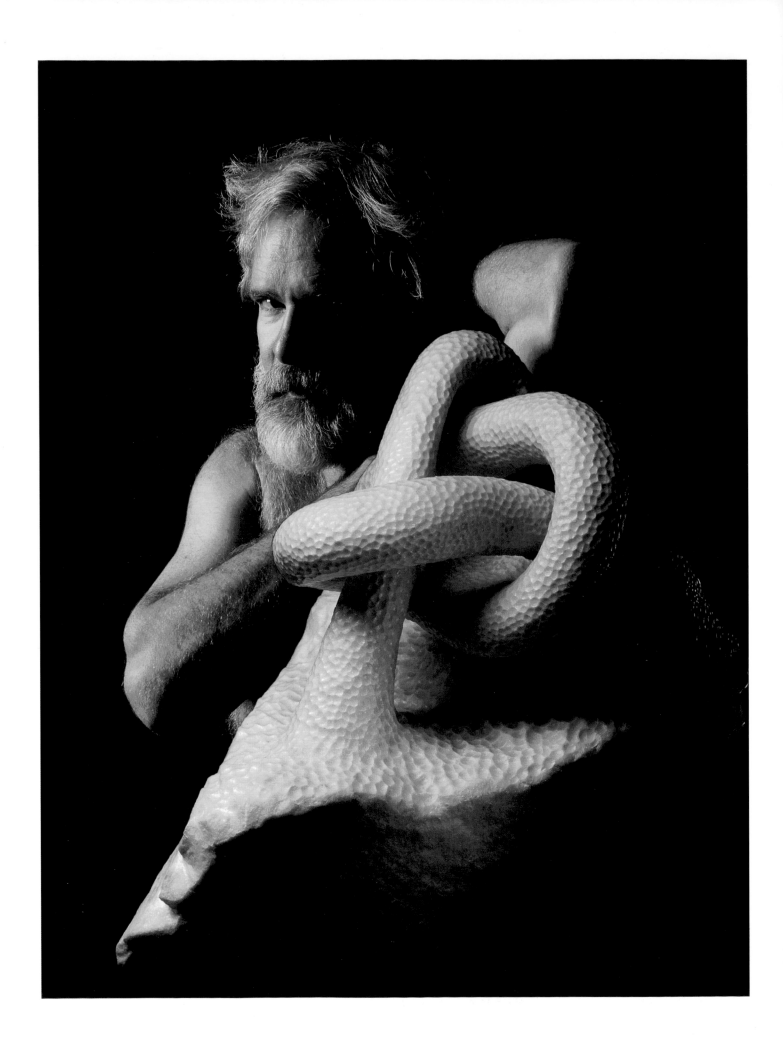

COMMENTARY

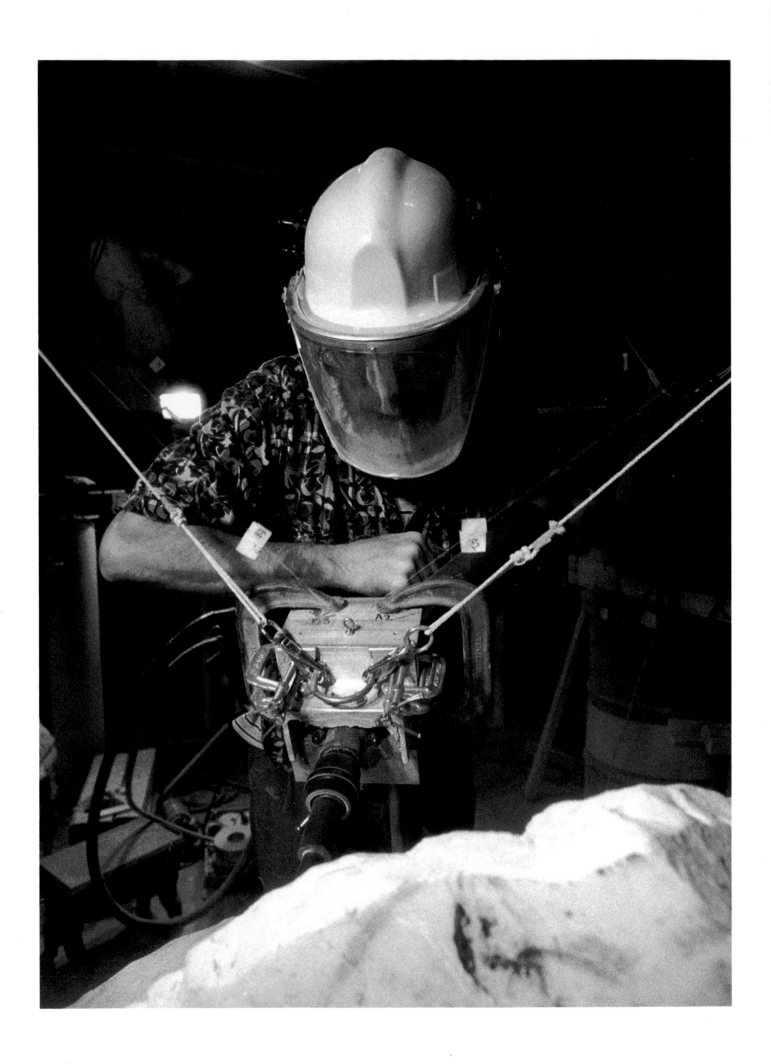

COMMENTARY

Alexander Horned Wild Sphere, Bronze.

A natural question about 3-space is what embeddings of the 2-sphere S^2 are possible [1]. One issue that I am addressing with this sculpture is when is something adequately defined, or as mathematicians quaintly put it, well-defined. $\pi_1(S^3 \setminus S^2)$ for a 2-sphere S^2 involves the question of whether small loops in the exterior of the sphere S^2 can be shrunk arbitrarily small. The answer is yes if the sphere is tame and no if the sphere is wild. An alternative title for my sculptures in this series is $\pi_1(S^3 \setminus S^2) \neq \pi_1(S^3 \setminus S^2)$. This is saying $A \neq A$ which simply means in this case that A is not well-defined, syntax equal, semantic unequal. But this is something we use in our everyday not-context-free language. For example, there is *Andrew*. Certainly *Andrew* \neq *Andrew* because *Andrew* alone does not define that Andrew Winkler who suggested the title of $\pi_1 \neq \pi_1$ for this sculpture and that Andrew Gleason who objected that this title would further torment if not turn off a mathematically naïve public.

1. C. E. Burgess and J. W. Cannon, *Embeddings of Surfaces in E^3*, published by the Rocky Mountain Mathematics Consortium, Rocky Mountain Journal of Mathematics **1** (Spring 1971), no. 2, 259–344.

Bivariate Cauchy Kernel, Serpentine.

This sculpture is also known as the Cauchy Kernel on the Bidisc. The theory of several complex variables (polydisc) is dramatically different than the theory of a single variable (disc). Let C denote the complex numbers.

Theorem. *Let P be the polydisc $\{z \in C^n : |z_j - a_j| < r_j, 1 \leq j \leq n\}$ with radii $r_j > 0$ and centers $a_j \in C$ and boundary $\partial P = \{z \in C^n : |z_j - a_j| = r_j, 1 \leq j \leq n\}$. Let f be continuous on both P and ∂P and holomorphic on each disc $\{z \in C : |z_j - a_j| < r_j, 1 \leq j \leq n\}$ separately. Then $(2\pi\sqrt{-1})^n \cdot f(z_1, \ldots, z_n) =$*

$$\int_{\partial P} \frac{f(\zeta_1, \cdots, \zeta_n)d\zeta_1 \cdots d\zeta_n}{(\zeta_1 - z_1) \cdots (\zeta_n - z_n)}$$

gives an integral representation of f for $z \in P$ with kernel $1/(\zeta_1 - z_1) \cdots (\zeta_n - z_n)$.

When $n = 1$ this is the classical Cauchy Integral formula where the integral is over a circle. For $n = 2$ (bivariate case) the integration is over a torus which is more sculptural. Suppressing the kernel involves directly integrating $f(z_1 + r_1 e^{\sqrt{-1}\theta_1}, \ldots, z_n + r_n e^{\sqrt{-1}\theta_n})$. For n=2, think of z_1, z_2, r_1, r_2 fixed and the θ_1, θ_2 free, the arguments are over a two dimensional torus surface generally in four dimensions. But the kernel $e^{-\sqrt{-1}(\theta_1+\theta_2)}/r_1 r_2$ does have expressive poles for r_1 or r_2 zero (crossing axes). Yet the integral is (depending

upon f) independent of the r_1, r_2. I combined the two aspects on a single torus in three dimensions with crossing independent cycles.

Still that didn't express what I wanted to say about the two independent circles around z_1, z_2. So I carved two separate tori each in a topological sense the exterior of the other, conveying the notion within the sculptural constraints of deformability of the tori, reflecting how topology enters into analysis. To further express the exterior-interior idea I severely incised the reptilian or amphibian form with crossing cycles and left ridges on the avian form. I also textured the Avian surface with an iteration of a Hilbert surface filling curve (2-adic Peano curve) and the Reptilian with the dual surface filling maze (which the curve threads throughout). The inside-outside is strict on the solid tori and texture, but not on the cycle choices, for contrast and to let an infinite process in the geometry leak out a little. This winding number counterpoints the inside-outside. Two matrices

$\begin{pmatrix} 1 & 0 \\ 0 & 1 \end{pmatrix}$ (Reptilian) and $\begin{pmatrix} 1 & 1 \\ 1 & 0 \end{pmatrix}$ (Avian) can be read off the cycles, reading rows of the matrices as intersection numbers, short and long ways. Powers of the Avian matrix give the Fibonacci sequence, recalling the phyllotaxic world where the avians and reptiles are at home.

1. R. Michael Range, *Holomorphic Functions and Integral Representations in Several Complex Variables*, Graduate Texts in Mathematics 108, Springer-Verlag, Heidelberg, (1986), 8.

Cosine Wild Sphere, Serpentine.

This is an incised torus wild sphere carved by virtual image projection with the SP–1 system. *(See Umbilic Torus NIST/SRC.)* In this case I desired a torus that was decidedly not a torus or revolution, I had a point to prove with the SP-1, this torus could not be made on a stone lathe for example. The virtual image in this case came from design equations that gave the torus a cosine profile when seen from the side. This is an alternative to inversion and cyclide tori for making a torus larger on one side. I have been interested in quarter periods of the cosine curve for some time. The changing radius curve in the virtual envelop for this incised torus carving lies in one such quadrant. The surface of this incised wild sphere seems to be covered with a thousand glistening eyes, these are residues of the virtual image projection carving process. As one approaches the virtual image and touches a nearby point, the computed radius for the sphere to be removed will appear smaller as you near. I stopped about a centimeter or so away from the virtual image and left the spherical cups. On one side, lower center there is a deeper indentation, below the level of the virtual envelope. In using the SP–1 at that time one of my sons was calling off the millimeters from the computer screen while I was drilling to depth. Somehow on that hole I started thinking centimeters instead of

millimeters. I caught my error before I came out the other side. Perhaps unfortunately this interesting sort of random element is less likely to occur with the more idiot proof SP–2, but then with the SP–2 there are other possibilities

Double Torus Stonehenge, 28 Silicon Bronzes.

This sculpture comprises a proof as well as a theorem. The proof in this case is much more valuable than the theorem. The germ of the proof can be used in many ways for many other theorems, and I have already discussed several other sculptures in terms of this circle of isogenies. The right hand isogeny path to an antipode is not quite the same as the left hand isogeny path. The idea works for proving that $3 \cdot x = x+h = x+2 \cdot x$. In this algebraic notation each one of the twenty-eight is simply $2 \cdot h$, a sphere with two handles or a double torus. The twenty-eight bronze double tori were cast from twenty-eight modeled wax originals. The antipodal double tori pairs are as far away from each other as the circular isogeny sequence permits. Given that these 28 are all attached to an oak disc which is really a sphere, the whole proof could be thought of algebraically as a surface $56 \cdot h$.

Eight Fold Way, Marble and Serpentine.

Under the qualitative marble topology is quantitative serpentine geometry. There is a general principle here that spawns theorems. This sculpture is also about symmetry of surfaces. A sphere with $g > 1$ handles cannot have infinite symmetry. Hurwitz Theorem [6,7] states that the group of automorphisms of a surface of genus $g > 1$ is bounded by $84(g - 1)$. The surface offered by the marble has genus $g = 3$. By Hurwitz the automorphism group can have as many as $84 \cdot 2 = 168$ elements. The literal automorphism group of the polished marble surface itself has only one element, but that surface is articulated in such a way that all 168 automorphism can be read out of it. There is an infinite discrete group associated with this marble acting on the hyperbolic plane that has a fundamental domain of exactly the 23 darker heptagons grouped around the 1 prism of the same dark polished stone. The discrete group in effect sews up the 24 heptagon domain into the marble surface of genus three. The marble has its 24 heptagons articulated as ridges and as incisions. The ridges correspond to the geodesic arcs in the hyperbolic plane which lie inside the fundamental domain, the incisions or cuts correspond to those geodesic arcs on the boundary of the fundamental domain. Select an edge somewhere on the marble. Go along this edge to the next fork in the road, take the left fork, go to the next and take the right fork, then left fork, then right fork, left fork, right fork, left, right and this is back to the original selection. There were eight turns, hence the title 'Eight Fold Way'. These 21 cycles return after eight alternating turns whatever the initial choice. The 168

elements of this group are the 3×3 invertible and commutator matrices [4,5] with entries over the two element field. We have to visualize this full symmetry genus three surface with more than our eyes, we need our fingers touching through these eight fold paths, our haptic sense of around and through, in addition to seeing.

The next generation of the virtual image projector, SP–2, was used in the creation of *Eight Fold Way*. SP–2 has six instead of three cables with all six lengths monitored by sensors arranged in Stewart platform format, [1]. The operator interactively flies the triangle. Tool tip position (x, y, z) coordinates and tool orientation (pitch, roll, yaw) are computed from the six cable lengths. Carving the *Eight Fold Way* included matching two stone parts, a hand shaped heptagon in the serpentine with a matching rounded heptagon on the tetrahedral marble form. The SP–2 helped. First the concave heptagon was carved in the marble. This heptagon was then touched with the tip of the inactive air drill to input a 'cloud' of points in no particular order close enough together. The three registration points were relocated in reversed order to carve the convex hand in the serpentine to hold the marble at its concave heptagon [2].

Most have seen the natural sculptural forms of the Grand Canyon carved out of solid rock by the abrasive Colorado River. I mused about capturing that sort of power in my studio. Looking over the south rim at the tiny filament of water glistening in the sun far below was about the filament size I saw close up in a water jet [3]. One significant difference was the noise; the water jet seems to compress millions of years of erosion into a few seconds of roaring tornado sound, churning the catch chamber below into white water. This violent roar comes from a filament of water issuing from a diamond orifice under 55,000 pounds per square inch pressure. The precise serpentine geometry counterpoints the free marble topology.

1. James Albus, Roger Bostleman, Helaman Ferguson, Samuel Ferguson, et al., *String-Pot Measurement System SP–2, hardware/software,* National Institute of Standards and Technology, NIST Draft Document (3 March 1993), 1–197.

2. Helaman Ferguson, *Computer Interactive Sculpture,* April 1992 Symposium on Interactive 3D Graphics, Computer Graphics, ACM SIGGRAPH Special Issue, 109–116, reprinted in The Visual Mind: Art and Mathematics (Michele Emmer, ed.), LEONARDO International Society for the Arts, Sciences and Technology and MIT Press, Cambridge, Massachusetts, 1993.

3. Helaman Ferguson, *Computers and Sculpture: Water Jets,* Invited paper for series in Maquette, a publication of the International Sculpture Center, David Furchgott/Director, 1050 17th Street, N.W., Suite 250 Washington, D.C. (March 1993), 11–12.

4. John H. Conway, R. T. Curtis, S. P. Norton, R. A. Parker, R. A. Wilson, with computational assistance from J. G. Thackray, *ATLAS of Finite Groups,* Maximal Subgroups and Ordinary Characters for Simple Groups, Clarendon Press, Oxford University Press, New York, (1985), i–xxxiii, 1–252.

5. Murray Gell-Mann and Yval Ne'eman, *The Eightfold Way,* reprint Chapter: The Eightfold Way: A theory of Strong Interaction Symmetry, California Institute of Technology Laboratory Report CTSL-20 (1961), W. A. Benjamin, New York, (1964), 11–57.

6. Adolf Hurwitz, *Mathematische Werke,* Band I Funktionentheorie. Band II Zahlentheorie, Algebra und Geometrie, E. Birkhauser & Cie, Basel, (1932-33).

7. Jonathan L. Gross & Thomas W. Tucker, *Topological Graph Theory,* Wiley Interscience Series in Discrete Mathematics and Optimization, John Wiley & Sons, New York, (1987), i–xv, 1–351.

Eine Kleine Rock Musik, III, Honey Onyx.

Many people ask me if a rock I am carving ever splits in two. This one split in three simultaneously. I suppose three was appropriate because I was carving $x + 2 \cdot x$ which is a variation of $3 \cdot x$ or three cross-caps on a sphere. But these three parts weren't cross-caps and they were on the floor. I was able to gather and glue together the 75 pounds of onyx and carve into its present 60 pounds. Fortunately for appearances the onyx is highly veined with some natural glues of its own. Only the radiance of the translucent cross-cap in the afternoon sun has kept me from destroying this piece for its lack of integrity.

Jaime Escalante Award, Bronze and Marble.

This umbilic inspired twisted torus is conceptually enveloped in a cyclide torus. A cyclide torus is a spatial inversion of a simple torus. An inversion relative to the unit sphere S^{n-1} in R^n is given for non-zero $x \in R^n$ by $x \mapsto x/|x|^2$, which takes x outside the sphere S^{n-1} inside and vice versa. Big things outside get squashed to small things inside. The vector x being non-zero defines a line through itself and the origin. The image of x under the inversion lies on this line. An inversion (relative to any sphere) takes spheres into spheres even degenerately thinking of a hyperplane as a degenerate sphere. Inversion transforms a simple torus intersecting a sphere in two discs into a cyclide torus big on one side, small on the other but the cross sections of the envelope are still circles. Such inversions have a lot to do with models of hyperbolic spaces in several dimensions. The cyclide form gives the *Jaime Escalante* piece its own ballast– it stands by itself even without the carved out footprint in the stone it clicks into. This is one umbilic torus where the stage of the Hilbert surface filling curve is physically a single closed inscribed groove on the cyclide torus surface. It took me twelve hours of cross-eyed needling to complete the full cycle.

Esker Trefoil Torus, Marble.

The esker curve is a $(2, 3)$ trefoil knot belonging to and somewhat typical of an infinite family of so-called *torus knots,* each parametrized by a pair of (relatively prime) integers (p, q). If p, q are not relatively prime then one can in a similar way have $d = gcd(p, q)$ disconnected links of $(p/d, q/d)$ torus knots. The line $qu - pv = 0$ in the (u, v) plane modulo 1 in both u and v directions gives recurrent line segments passing through the unit square which eventually close on themselves. The (u, v) modulo 1 in both directions gives the unit square the structure of a torus as opposite sides are identified. The plane covers the torus infinitely often via the mappings summarized by

$$\mathbf{Z} \times \mathbf{Z} \hookrightarrow \mathbf{R} \times \mathbf{R} \Rightarrow \mathbf{R}^2/\mathbf{Z}^2 = S^1 \times S^1$$

This is one example of the underlying discrete group scenario that I find sculpturally inspiring and fertile. The $(2, 3)$ torus knot is just a circle, but I am supporting it as a crenulated ridge on a discrete group torus. This knot goes about the torus twice the long way and thrice the short. The wandering of a torus curve gives rise to pairs of counting numbers. We write the label of a torus knot as (p, q) which is itself a vector. The basis vectors $(1, 0)$ and $(0, 1)$ represent (trivial) torus knots themselves. Every torus knot can be written in terms of these two, e.g., $(2, 3) = 2 \cdot (1, 0) + 3 \cdot (0, 1)$. Thus we have an algebraic language with which to discuss these sculptural structures. The crenulations themselves are termini of polished grooves giving a vector field, or texture dynamic on the surface.

Essential Singularity, Aluminum.

The formal series expansion

$$e^{1/z} = \sum_{n \geq 0} \frac{1}{n! \, z^n}$$

exhibits an infinite sum of terms each of which blows up for $z = 0$. Subtracting one leaves infinitely many still. For z a real variable $e^{1/z}$ is positive, the graph lies in two dimensions and is a piecewise one dimensional curve with a infinite break at $z = 0$. Too little for sculpture. For z a complex variable the three dimensional graph lies in four dimensions. Too much for sculpture. So I crush this by looking at the absolute value of the graph which is now two dimensions in three. This new function $|e^{1/z}|$ still has the infinite blow up feature at $z = 0$ although the infinitely many terms above are obscured a bit. If $z = x + y\sqrt{-1}$ then $|e^{1/z}| = e^{x/(x^2+y^2)}$. Level curves of this function are circles of the form $cx = x^2 + y^2$ tangent to the origin, centered on the real axis, on the right for $c > 0$ and $|e^{1/z}| > 1$ and on the left for $c < 0$ and $|e^{1/z}| < 1$ with radii as on the real positive curve above. I took a stack 40 steps above 1 and 10 steps below 1. This discretization destroys the mathematical model save at the edges, and introduces the human element of steps, stepping up the spire, stepping down into a pool. We can relate to steps, we have two feet and set them down discretely. We might relate to the pure model being infinitely smooth except at one point if we slithered as well as snakes but we don't. Would footless whales if so inclined find evaluating integrals of smooth functions more natural than evaluating discrete sums? This piece was completed some time ago and was a clear sculptural departure both in material and aesthetic choices from the rather literal and purely representational plaster mathematical models once visible in many math departments [2].

1. Eugene Jahnke and Fritz Emde, *Addenda, VI, The exponential function $e^{1/z}$*, Tables of Functions, Dover, (1945), 39.
2. Gerd Fischer, *Mathematische Modelle / Mathematical Models*, Friedr. Vieweg & Sohn, Braunschweig/Wiesbaden, (1986), volumes I: i–xii, 1–129; II: i–viii, 1-83.

Figure Eight Knot Complement I, Polished Silicon Bronze.

The figureight knot F_4 in the three sphere S^3 is the simplest non-torus knot. F_4 can be thought of embedding in but wriggling about in S^3 in many ways, a very topological qualitative image. The wonderful discovery was [1] that even so, the complement or everything but F_4 (i.e., the space $S^3 \setminus F_4$) has rigid or quantitative structure of a three dimensional hyperbolic space, a quotient under a discrete group. The fundamental group $\pi_1(S^3 \setminus F_4)$ is generated by two independent loops in the complement, α and β, (looping opposite sides of the knot in the usual planar presentation with a center twist) with a single relation, $(\alpha\beta^{-1}\alpha^{-1}\beta)\alpha = \beta(\alpha\beta^{-1}\alpha^{-1}\beta)$. The two matrices $\begin{pmatrix} 1 & 1 \\ 0 & 1 \end{pmatrix}$ and $\begin{pmatrix} 1 & 0 \\ -\omega & 1 \end{pmatrix}$ satisfy this relation and the correspondence gives a representation of $\pi_1(S^3 \setminus F_4)$ onto a discrete subgroup Γ that lies in the Bianchi group $PSL(2, Z[\omega]) \subset PSL(2, C)$, where ω is one of the complex cube roots of -1, $1 + \omega + \omega^2 = 0$. The end result is that $S^3 \setminus F_4 = H^3/\Gamma$ where H^3 is hyperbolic 3-space, [2]. I cast the symbols H^3/Γ lightly into the bronze of this piece, but there are structural features as well. The two surfaces, one polished one satin, recall the two generators. The raised ridge or esker reveals a simple closed curve around which one can run ones finger. The finger has to lift and reach around the double torus to where it left off, so the finger makes these little secondary loops in the complement. These digital circuits are reflected in the powers of the α and β and their mixed products.

1. R. Riley, *A Quadratic Parabolic Group*, Mathematical Proceedings of the Cambridge Philosophical Society **77** (1975), 281–288.
2. John Milnor, *Hyperbolic Geometry: The First 150 Years*, Symposium on the Mathematical Heritage of Henri Poincaré, April 7-10, 1980, Bulletin (New Series) of the American Mathematical Society **6** (January 1982), no. 1, 9–24.

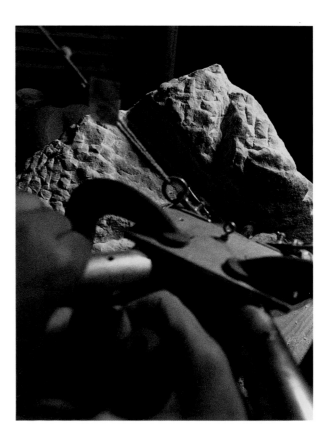

Figureeight Knot Complement II

In this sculpture the featured ridge curve between the polished marble and the honeycombed marble is the Figure Eight Knot. Here the relevant Kleinian group is $\Gamma \subset PSL(2, Z[\omega]) \subset PSL(2, C)$ and $\omega = -\frac{1}{2} + \frac{\sqrt{-3}}{2}$. as discussed in *Figure Eight Complement I*. The ring $Z[\omega]$ has all of its elements lying discretely in the complex plane C in the form of an equilateral lattice generated by all of the cube roots of ± 1. These six cube roots form a hexagon lying on the unit circle given by $\omega, -1, -1 - \omega, -\omega, 1, 1 + \omega$ in counterclockwise order. The equilateral lattice contains the sublattice generated by $1 + 2\omega$ and $2 + \omega$. Call this the lattice of centers. Then the whole equilateral lattice is given by these centers and translates of the unit circle hexagon. Now the marble has two textures, polished and so-called honeycombed. The honeycombed texture was developed by thinking about this lattice of centers and hyperbolic geodesics.

The Figure Eight Knot F_4 has a special property that makes it unique among all hyperbolic knots. It is the only hyperbolic knot which is also *arithmetic* as proven recently by Reid [1]. An arithmetic Kleinian group comes from the group of units of an order of a quaternion algebra over a number field. The number fields involved in this case are quadratic $Q(\sqrt{-d})$ for integers $d > 0$. Reid's proof eliminates all the cases except $d = 3$ which is when the ring of integers of $Q(\sqrt{-3})$ is exactly $Z[\omega]$ which is also the $Z + \omega Z$ behind the honeycomb lattice carved locally in one of the Seifert surfaces of the Carrara marble.

1. Alan W. Reid, *Arithmeticity of Knot Complements,* Journal of the London Mathematical Society **43** (1991), no. 2, 171–184.
2. Benjamin Fine, *Algebraic Theory of the Bianchi Groups,* Marcel Dekker, Inc, New York and Basel, (1989), 249.

Figure Eight Complement III, Marble.

F_4 is the unique amphichairal, arithmetic, hyperbolic knot with four crossings. There is something interesting about linking going on with this sculpture. I and II in this series has an F_4 embedded on a simple double torus which separates the double torus into two (linked) twisted two-holed annuli. This sculpture III exhibits F_4 embedded on a double torus with a (pseudo) link as in one of the *Stonehenge* elements. So this embedding gives F_4 as a boundary of a single twisted self linking surface covering the double torus. Francis's [1] has some inspiring complex hand drawn pictures of such twisted surfaces and the figure eight knot. Of course inserting double torus into an appropriate *Stonehenge* circle and continuing around to the antipode which is a simple double torus gives an embedding of F_4 on a simple double torus, but a much more complex embedding than appears in either *Figure Eight I* or *Figure Eight II*. Indeed, III is a fragment of such an unfinished *Stonehenge*.

1. George K. Francis, *A Topological Picturebook,* Springer-Verlag, New York and Berlin, (1987), xvi + 194.

Five Fold Umbilical Cord Torus, Styrofoam.

The curve at the core of this piece is a torus knot type $(p, q) = (1, 5)$, which is not a knot at all or is the unknot or is the trivial knot. This unknot can be drawn on the surface of a simple torus, which I did in the final direct carving process. I charged up my system to do the direct carving by alternating between two activities: 1) generating equations for umbilical cord forms and then testing these by making stereo pairs of computer graphics output to look at. 2) dissecting actual umbilical cords given to me by friends, not the first time I dissected. The three cord segments were quite interesting and I made a small number of clay models or maquettes about them or particular features. But I generated maybe a hundred computer stereo 3D images about them much faster than it would be possible to physically make them or things like them. The virtual studio of the computer screen need not be a sterile environment if coupled with actual studio experience. A topologically equivalent example of the five fold core space curve on the simple torus for this sculpture is given by the simple vector valued function of one variable $t \mapsto ((3+\cos 5t) \cos t, (3+\cos 5t) \sin t, \sin 5t)$ where the circle of minor radius 1 cycles five times for each single cycle around the circle of major radius 3. This space curve can be given cross-sections in various ways and built up into a torus in its own right. After all this preparative emotional and conceptual loading, the direct carving went quite rapidly.

Four Identifications of a Square, Kodachrome Alabaster.

The four two dimensional surface shapes immersed in three dimensions are named by the symbolic but descriptive algebraic expressions $0, x, h, 2 \cdot x$. Here 0 denotes the sphere, x the cross-cap on a sphere, h a handle on a sphere which is the same as a torus. The next expression $2 \cdot x$ or $x + x$ has a definable plus sign for adding two shapes. The common name of $2 \cdot x$ is a Klein bottle which has several incarnations known by no other name. $2 \cdot x$ is intrinsically meaningful once x and $+$ are defined. x itself has several historical names, the alabaster carving is closest to the one known as Boy's surface which since 1901 has tended to be attached to an immersion of x with a triple point. Apéry [1] has realized a Boy immersion as an algebraic surface of degree six with coefficients in the algebraic integers $Z[\sqrt{2}]$. A hypocycloid of three cusps appears in the middle of Apéry's construction.

The words $0, x, h, 2x$ are just the first four steps in a complete algebra of closed compact surfaces without boundary (without boundary means no unsewn edges). All of the elements of this algebra are of the form $m \cdot x + n \cdot h$ for integers $m, n = 0, 1, 2, 3, \ldots$. The classification theorem [2] for surfaces (two

dimensional manifolds) states that *every* closed compact surface without boundary appears in this list. The same surface can be listed more than once. For example, $3x = x + h$ which is a fundamental one, as $2 \cdot x$ (Klein bottle and not orientable) is certainly not the same as h (torus and orientable). This cross-cap is the other half of the story of surfaces and it is about time it has received conscious sculptural attention.

1. François Apéry, *La surface de Boy*, Advances in Mathematics **61** (September 1986), no. 3, 185–266,
2. Stewart Scott Cairns, *Introductory Topology*, Drawings by Ali R. Amir-Moez, Chapter 2: Topological Classification of Surfaces, Ronald Press Company, New York (1961).

Igusa Conjecture, Serpentine.

When Jun-Ichi Igusa of The Johns Hopkins University makes a conjecture, mathematicians listen [2, 3]. He bases them on hard won but important examples that may take him months and years to compute. His examples are precious mathematical treasures by themselves. His local zeta function is a rational function

$$Z(s) = \int_{\chi(O_\kappa)} |f(x)|_\kappa^\Re \, dx, \quad \Re(a) > 0,$$

where K is a P-adic field with absolute value $|.|_\kappa$, ring of integers O_κ, f a polynomial on an affine space χ with O_κ structure. For the present example, $f(x_1, x_2)$ is the discriminant of the binary cubic form $N(ux_1 - vx_2)$ in u, v where x_1, x_2 are from a simple K-split Jordan algebra A of degree 3 with generic norm N. The 'simple' in the last sentence is anything but simple.

The case enjoyed by the sculpture is $X = H_3(C(O_\kappa)^2$ where C is a composition algebra of dimension $2n$ with an O_κ-hyperbolic norm form. Then $Z(s)$ takes the form [1]

$$Z(x, y) =$$

$$\frac{(1 - x)(1 - x^2)(1 - x^{n+1})(1 - x^{2n+1})}{(1 - x^2 y^2)(1 - x^5 y^6)(1 - x^{2n+1} y^2)(1 - x^{2n+2} y^4)} \cdot$$

$$\frac{F(x, y)}{(1 - x^{3n+3} y^6)(1 - x^{6n+2} y^6)}$$

where the polynomial $F(x, y)$ has 140 terms, where $x = q^{-1}$, $y = q^{-s}$, $n = \dim C/2 \neq 1/2$, and q is relatively prime to 6. In spite of this complexity, the functional equation $Z(x^{-1}, y^{-2}) = y^{12} Z(x, y)$ is true [3].

On the other hand the eigenvalues of monodromy for the binary cubic form f *(quite independently of the local zeta function Z)* are $\exp 2\pi v \sqrt{-1}$ for a zero u of the Bernstein polynomial

$$B(s) = (s + 1)^2 \left(s + \frac{5}{6}\right)\left(s + \frac{7}{6}\right)\left(s + \frac{n+1}{2}\right)^2.$$

$$\left(s + \frac{n+2}{2}\right)^2 \left(s + \frac{2n+1}{2}\right)^2 \left(s + \frac{3n+1}{3}\right)\left(s + \frac{3n+2}{3}\right)$$

Igusa's conjecture is that in general the poles of the local zeta function including multiplicity lay among the zeros of the Bernstein polynomial and thus correspond to the eigenvalues of monodromy, ef., [2].

I divided the stone into two parts, that referring to the poles and that referring to the eigenvalues. One might think: well, $Z(x, y)$ is just a rational function, why not just graph it or, since it is complex valued, it's absolute valued. I tried that just to develop some insight. That shows next to nothing, the dynamic range of this polynomial is such that there are not enough protons in the known universe to begin to draw a picture that shows more than a tiny bit. So I retained the idea of the absolute value idea as I did in *Essential Singularity* (these poles are removable) and created spire-like forms over the relative positions of the poles. I kept in mind that if one could see much of the first the others would be invisible, so I cut more stone off as the poles got more distant. Between the poles and eigenvalues I carved a sort of a water line as a ship has, it is the nature of conjectures that one thinks from time to time: Will it float? Will it sink? The eigenvalues on the other hand are abundantly visible. In this case they all fall on six points equally spaced around the unit circle as they are the three complex roots of 1 and the three complex roots of -1. For the example at hand, there are two eigenvalues not coming from poles, those I did not arch along radii from the center as I did the four eigenvalues that did come from the poles. The sculpture can stand on its eigenvalues. I have carved this stone celebrating Igusa's conjecture. Isn't that risky? The conjecture may turn out to be false. The nature of Nature is risk. For the moment I will think that the stone would have come apart during the carving process if the conjecture were false.

1. Jun-Ichi Igusa, *Local Zeta Functions of Certain Prehomogeneous Vector Spaces*, American Journal of Mathematics **114** (1992), 251–296.
2. T. Kimura, F. Sata and X.-W. Zhu, *On the poles of p-adic complex powers and the b-functions of prehomogeneous vector spaces*, American Journal of Mathematics **112** (1990), 423–437.
3 Diane Mae Meuser and J. Denef, *A Functional Equation of Igusa's Local Zeta Function*, American Journal of Mathematics **113** (1991), 1135–1152.

Incised Torus Wild Sphere, Polished Bronze.

The *Alexander Horned Sphere* was made by selective extrusion from a ball. This incised torus wild sphere offers another construction almost dictated by the fact that I began by carving stone. First I carved a torus, holed the stone. That says the stone is good and lets in some light. Then I carved a double torus $2 \cdot h$ with linked handles. Then I incised both handles

separately (this really tested the stone) leaving four linked handles or 4 • h. The interesting part is thinking ahead to leave the right spaces between the overlapping arms. 4 • h was as much as this stone could stand. Perhaps if I were a craftsman I would have stopped right there with those four nice carved chain type links. All along during the incising I was thinking about how one gropes within for an elusive idea. At the moment I seized it, I broke open the four handles reducing the 4 • h to 0, a sphere once again, but now wildly illuminated.

Joined Trefoil Figure Eight Esker Complement, Serpentine.

This trefoil with two limbs joined is a double torus which bears an embedded non-self-intersecting F_4. In this carving a knotted circle is sculpted relative to some crystals that do have area and volume and mass. An esker or ridge indicates where the knot might be. But the second feature of interest is the complement of the knot, not that the knot is ignored but that it is purposely not there. This joined trefoil double torus bearing the knot on its delicate edge is mostly in the complement, but then so is the outside space and the viewer and toucher who is paying attention to the knot not there. The space of loops embedded in the complement of the knot F_4 is denoted symbolically by $\pi_1(S^3 \backslash F_4)$ and is a non-abelian group with two generators. $S^3 \backslash F_4$ is even more highly structured with ideas that reach into many parts of mathematics. For example, it has hyperbolic volume $2.029883212819307250042405108549\cdots$ a number which can be computed to thousands of decimals but about which we know nothing, whether rational or irrational, whether algebraic or transcendental.

Three Knots, Four Silicon Bronzes.

Equality has to be defined. Here two knots are equal if one can be continuously deformed into another or equivalently if there exists a *Stonehenge* dance kind of proof, taking one to the other by small continuous deformations without self-intersections and back again. This sculpture includes the two torus knots, one represented by $(2, 3)$ and the other represented by its mirror image $(-2, 3)$. The label difference is not enough, $(1, 1)$ is the same as $(-1, 1)$. To prove that these two mirror images are not deformable one into the other requires real mathematical work. One issue that has to be dealt with is that knots only exist in three dimensions, any three dimensional knot can be completely untied in four dimensions, just one new independent direction suffices to relieve all the over and under crossings.

$(2, 3)$ and $(-2, 3)$ are the only two knots with three crossings, the crossing number of a knot being the least number of over and under crossings when the knot is drawn in the plane. The trivial knot or unknot or simple circle has crossing number zero. There are no single circle knots with crossing number one or two. There is only one knot with four crossings and that one

is F_4. Given that and that the remaining two bronzes each have four crossings even though they are mirror images of each other proves that the two mirror images can be deformed one into the other. It is easy to verify that the two mirror images are the same with a pair of shoelaces.

Three Spheres, Bronze.

Three steps of an infinite process leading to a wild surface. Give 1, 2, 4 and 8, 16, 32 follow logically because a doubling rule is a natural perception (there are many other possibilities). Here the bifurcation is binary but that is not all. Suppose the sphere just kept bifurcating without linking where would the thing end up. The linking as indicated adds a new element which makes the binary splitting end up on a perfect compact closed totally disconnected (Cantor) set. This set is isomorphic to a set defined by successively removing middle thirds from the unit interval and remaining subintervals. Let $2 = \{0, 1\} \ni \epsilon_k$ and $3 = \{0, 1, 2\}$ not be confused with $k \in \mathbf{N} = 1, 2, 3, \ldots$. Then the unit interval of measure one loses its middle thirds and goes into the Cantor set of measure zero by

$$2^{\mathbf{N}} \ni \sum_{k \in \mathbf{N}} \frac{\epsilon_k}{2^k} \mapsto \sum_{k \in \mathbf{N}} \frac{2\epsilon_k}{3^k} \in 3^{\mathbf{N}}.$$

To be the wild sphere endpoints the Cantor set must be wild too. Even so it is a fractal as it has Hausdorff dimension $\frac{\log 2}{\log 3}$, not an integer. This suggests the elegant if flagrant abuse of notation

$$3^{\mathbf{N}} \hookleftarrow 2^{\mathbf{N}} \simeq 3^{\frac{\log 2}{\log 3}\mathbf{N}}$$

which perhaps no one in their left brain would dare write down. So three, 3, is an interesting choice for the number of bronzes in this piece, even though I have two spheres with bifurcations at two levels and four levels and the other is a doubly pinched double torus (not really a sphere) unstably poised between spheres, hesitant between bifurcations.

1. K. J. Falconer, *The Geometry of Fractal Sets*, Cambridge Tracts in Mathematics 85, Cambridge University Press, Cambridge and New York, (1985), 14.

Thurston's Hyperbolic Knotted Wyes I, Marble.

The underlying mathematical theme of this multifold Carrara marble carving is the classification of 3-manifolds and 3-orbifolds along the lines of a research program initiated by Thurston for understanding 3-manifolds around which the NSF Geometry Center at the University of Minnesota has been built. The 2-manifolds or surfaces can all be classified in terms of the action of discrete groups on three universal covering spaces: the positively curved sphere S^2, the zero curvature plane or

Euclidean plane R^2, and the negatively curved or hyperbolic plane H^2. Essentially, the surfaces can be given as quotients of these two dimensional spaces by appropriate discrete groups. Thurston's program suggests that all 3-manifolds can be classified and understood by taking discrete group quotients of the eight universal covering spaces. Three of these are direct analogs of the two dimensional ones, S^3, R^3, H^3, two are products of them, $S^2 \times R$, $H^2 \times R$, and three others are more remote: infinite cover of $SL(2, R)$, the Solv-manifold, the Nil-manifold.

There are two common models for visualization of three dimensional hyperbolic space, the upper half space and the interior of a ball. Both have four geodesics arcs of circles perpendicular to the boundary. In each case, rotating the arc about its perpendicular bisector carves out a spherical void or scoop, or alternatively exposes a hemisphere. The knotted graph of two vertices and three edges for this piece lies virtually in the core of the marble. Since the complement conceptually bears the hyperbolic structure, I expressed this symbolically by carving these spherical voids in the marble.

Thurston's Hyperbolic Knotted Wyes II, Marble.

This configuration can be decoded from a verbal description of the planar presentation by saying the first link over, under, over, under, the second link under, over, and the third link over, under, over, under, going in each sequence from the first vertex to the second vertex. This Carrara marble was preceded by the smaller *Knotted Wyes I*. Both are direct carvings. Al Marden, director of the Geometry Center, saw *Knotted Wyes I* at an exhibition. He said they really needed a sculpture like this at the Geometry Center, because the people at the University there did not understand what they were really about. He went on to say that people thought they were computer hackers or something because the Geometry Center uses heavy computer graphics as research tools for gaining insight into geometry. He noted that they were misunderstood in this way and that if they had a sculpture like that people would understand instantly that they were mathematicians, that they were artists. A lot of creative mathematicians are not frustrated artists or anything, they really think of their science as an art form. *Knotted Wyes II* will communicate this understanding for many generations. I set this 1500 pound stone up on four oak cuboids, again rigid geometry underlying the fluid topology. As soon as the dedication was over for this piece there was a pause, a collective breath, and everyone it seemed rushed forward to touch this marble carving, climbing all around it, reaching past each other, holding hands through its various limbs. These were adults. I loved that moment.

Torus with Cross-Cap and Vectorfield, Marble.

The vector field here is used to articulate the cross-cap. The cross-cap is a new artifact in sculpture. Tangent vector fields are like fingerprints or hair that lies flat. The tangent vector field gives a system of directions on a surface that obey certain intrinsic rules depending upon the topology of the surface. For any dimensions, if M is a compact manifold with a smooth vector field v with only isolated singularities of full rank, $\xi_1, \ldots, \xi_j, \ldots \xi_k$ then

$$\sum_{1 \le j \le k} sign(J_{\xi_j}(v)) = \sum_{0 \le i \le \dim M} (-1)^j \dim H_j(M),$$

where $J_\xi(v)$ is the Jacobian of v at ξ, $sign(t) = t/|t|$, $H_i(M)$ is the j^{th} homology group of M, and the right hand side is $\chi(M)$, the Euler-Poincaré characteristic of M.

Given a general theorem like this I get to choose the sculptural dimensions. The left hand side counts singularities of the vector field and when the characteristic is zero (for dim $M = 2$ a torus) there need not be any singularities at all. But on this torus with cross cap sculpture there is a torus part and I have carved the vector field of polished grooves about the handle in a parallel form. At the cross cap I carved them in such a way that they go horizontally on one cross-cap branch continuing horizontally through the vertical line of intersection. On the other branch they pass vertically and parallel through the line of intersection.

Torus with Cross-Cap, Silicon Bronze, Polished.

An algebraic name for this is $x + h$ where the $x + h$ comes from an algebra taking values in shape or surface structure not numbers. The rules of this algebra are different because addition combines shapes. The context equation for this bronze is $3 \cdot x = x + h$, so one naturally thinks $x + 2 \cdot x = x + h$ and cancel the leading x to get $2 \cdot x = h$? But $2 \cdot x$ is a Klein bottle and h is a torus and no amount of polishing makes them the same.

Transversality, Serpentine.

The rewards of the subtle but simple notion of transversality [1] are the beautiful and true classification into canonical forms of singularities of stable mappings [2]. Among the jewels to be found there are the hyperbolic, elliptic, and parabolic *umbilics* which are given a context among a class of smooth functions much broader than polynomials.

Thom Transversality Theorem. *Let X, Z be smooth manifolds and Y a submanifold of the bundle of k−jets from X to Z. Then the set*

$$\{ f \in C^\infty(X, Z) \quad | \quad j^k f \;\overline{\pitchfork}\; Y \}$$

is a dense (topologically large) subset of $C^\infty(X, Z)$ in the Whitney C^∞ topology.

The k−jet idea here corresponds to the first $k + 1$ terms of the formal Taylor series of a smooth function, analytic or not. It is a sensitive generalization of local approximation of smooth functions by polynomials and all derivatives up to a certain point. The process of carving stone with a point is like forming a 0−jet bundle, a toothed chisel or grinder like a 1−jet bundle, polishing to some k^{th} degree like a k−jet bundle, throughout the process keeping in mind the topological equivalence among the maps and selecting expressive or fertile equivalence class representatives. The transversality theorem dictates nothing whatsoever to nature or the minerals being carved, yet offers clarifying language.

1. John N. Mather, *Stability of C^∞ Mappings, V,* Transversality, Advances in Mathematics **4** (June 1970), no. 3, 301–336.
2. Martin Golubitsky and Victor Guillemin, *Stable Mappings and Their Singularities,* Chapter II: Transversality, Springer-Verlag, New York, Heidelberg, Berlin, (1973), 50–54.

Umbilic Torus NC, Bronze

These two Umbilic Tori NC and NIST/SRC are dual, each is a compactification of the exterior of the other. The action of the general linear group of 2×2 invertible matrices with real entries on binary quadratic forms has invariant the familiar quadratic $b^2 - 4ac$ discriminating among hyperbolas, ellipses, and parabolas. The corresponding sculpture is a circle. For binary cubic forms the invariant is the quartic $b^2c^2 - 4ac^3 - 4b^3d + 18abcd - 27a^2d^2$ discriminating among hyperbolic umbilics, elliptic umbilics, parabolic umbilics, and exceptionals. Depending upon the point of view, the two corresponding sculptures are the Umbilic Tori. Choosing the hyperbolic umbilics at infinity leads, [1], to the NC cross-section, $v = 2e^{i\phi} - e^{-2i\phi}, 0 \le \phi < 2\pi$. This is the locus of a point on a circle of radius 1 rolling inside a circle of radius 3, otherwise known as a hypocycloid of three cusps (not a triangle).

The initials 'NC' represent 'numerically controlled' and mean 'mindless robot'. I selected, [2], the robot cutter tool path for carving out the surface of *Umbilic Torus NC* to be a surface filling Hilbert curve, which is a 2-adic version of Peano's suite of q-adic curves, $q = 2, 3, 4, \cdots$.

1. Helaman Ferguson, *Two Theorems, Two Sculptures, Two Posters,* Invited paper for the 75th Anniversary Issue of the Mathematical Association of America, Cover and Sixteen Figures, American Mathematical Monthly **97** (August–September 1990), no. 7, 589–610.

2. Helaman Ferguson, *Space-Filling Curves in Tool Path Applications,* with Jordan Cox, et al., Special issue on NC Machining and Cutter Path Generation, Byoung K. Choi/guest editor, Computer Aided Design (CAD) (February 1994).

Umbilic Torus NIST/SRC, Marble and Serpentine.

This sculpture is the dual of the *Umbilic Torus NC.* We go back to a fork in the design road and choose the elliptic umbilics to be a neighborhood of infinity. This leads to $w = 2e^{i\varphi} + e^{2i\phi}, 0 \le \varphi < 2\pi$ as the NIST/SRC cross-section. This is the locus of a point on a circle of radius 1 rolling outside a circle of radius 1, otherwise known as an epicycloid of one cusp, or a cardioid.

This outward curving form with internal cusps offers new sculptural challenges so I used virtual image projection, [1], for direct carving in natural stone. In the SP–1, three computer monitored cables under tension meet at a point. Three distinct labeled points in general position on a block suffice to determine the position and location of the block. The virtual image for this sculpture was in the computer in the form of parametric equations [2]. The software includes an algorithm which calculates from any given point in space the nearest distance from that point to the virtual image. In the *SRC* piece, I left partially carved out maximal spheres looking out of the base like microwave antennae revealing the origins of the polished stone they support.

1. James Albus, Roger Bostleman, Helaman Ferguson, Samuel Ferguson, et al, *Functional Description of a String-Pot Measurement System, SP–1,* National Institute of Standards and Technology, NIST Draft Document (6 April 1990), 1-76.
2. Helaman Ferguson, *Multiperiodic functions for surface design,* with Alyn Rockwood, Computer Aided Geometric Design **10** (1993), 315–328.

Whaledream $ii + i$, Serpentine.

Carving this $\pi_1 \neq \pi_1$ was pure subtraction from the stone. Subtraction is a natural formative process, our fingers and toes would still be webbed except for the fact that we have cells genetically programmed to die. I thought about that as I removed the webbing from this stone, exposing the linking arms. The generators of the fundamental group of the exterior of the type of wild sphere of this *Whaledream W^2* occur in pairs indexed by all binary bit sequences $\quad k \ge 0, \beta_0 \ldots \beta_j \ldots \beta_k, \beta_j = 0, 1$. The relations involve pairs of commutators $[a, b] = aba^{-1}b^{-1}$. Finally [1],

$$\pi_1(S^3 \setminus w(S^2)) =$$

$$\langle \quad a_{\beta_0 \ldots \beta_k}, \quad b_{\beta_0 \ldots \beta_k} \quad \ldots |$$

$$a_{\beta_0 \ldots \beta_k} = [a_{\beta_0 \ldots \beta_k 0}, \quad b_{\beta_0 \ldots \beta_k 0}],$$

$$b_{\beta_0 \ldots \beta_k} = [a_{\beta_0 \ldots \beta_k 1}, \quad b_{\beta_0 \ldots \beta_k 1}] \quad \rangle.$$

This group gave an infinite genetic programming of which crystals of the stone were going to die not with extreme prejudice but with extenuated foreknowledge.

1. James W. Cannon, *The Fundamental Grope,* That is right, grope, not group, private conversation.

Whaledream II, Marble.

This 550 pound Carrara marble piece is really an incised torus which started out like a cyclide torus. I did the torus part leaving the stone split-faced and raw with only vague hints of the next stage. It sat around for a couple of years waiting for me to work up courage. I really wanted to continue carving the four limbs which are the size of people arms. I was scared to carry the project through thinking that the stone couldn't take such wild sphere status. At the time I was professor at a university that did not allow the public display of some beautiful 18th and 19th century marble figures that someone gave its art collection. I didn't know about them but a friend of mine had the keys and he let me in after hearing about my particular crisis. There they were, Carrara marble figures, some with extended and unbroken arms. I sounded out these carvings; that gave me solid reasons to continue my work. Ironically this very piece is now on loan to that institution and is as publicly displayed as anything there ever could be. Of course, if certain someones there read this that will be the end of that.

Wild Ball, Wild Tree, Silicon Bronze.

This Ball and Tree sculpture offers the fundamental iteration of Bing's astounding construction. A ball and tree sculpture is informally solid, the Bing iteration pertains to the surface. Take a sphere and map a dodecahedron on it. Let a feeler with a handle (hole) on the end sprout from the center of each pentagon in such a way that each feeler grows through the handle of just one neighbor. This surface has genus 12. Now fix that arrangement and remove a segment from each handle. The result is a sphere of genus 0 again but with twelve trees, each having two branches. Now think of this tree as a sphere in its own right and tile it with twelve pentagons each sprouting a linking tree as before. Note that the removed segments are replaced by a linking subtree. This surface has genus 144. Now fix that and remove 144 segments and continue on with each of that gross of trees to get 1728 and so forth. The $\tau\epsilon\lambda o\varsigma$ of Aristotle as it were of this thing is a wild sphere with no wild subarcs.

I chose the ball and tree sculptural elements for their innocence. With this construction careening around in my mind, naked as worms, I fixed the basic pair in something solid. I made solid positive wax forms, invested these in a mixture of plaster, luto, and ceramic type materials to make negative images. I fired these flasks in a kiln until they vitrified, then buried them in sand and poured molten bronze into them to make the final positive bronze image. They are solid bronze and correspondingly massive. The bronze treelets don't wave in the wind but do emit interesting chords when tapped with a hammer, music of the wild spheres.

1. R. H. Bing, *A wild surface each of whose arcs is tame* **28** (1961), 1–15.

Wild Singular Torus, Marble.

There are wild spheres so why not wild tori. The Antoine-Alexander construction of a wild sphere involves a construction of a wild Cantor set which has uncountably many points. Using their ideas of knot theory Fox and Artin [1] revealed a wild sphere with just one wild point. This carving offers a torus surface with a wild arc which is the union of two tame arcs with a fundamental group defined by infinitely many generators a_n, a_{n+1}, \ldots and infinitely many relations $a_n a_{n+1} a_n = a_{n+1} a_n a_{n+1}$, for $n = 1, 2, 3, \ldots$, a non-abelian group because of the permutation representation $a_n \mapsto (2, n \bmod 2)$ into the permutation group on three ciphers 0, 1, 2. This is a one thousand pound celebration of one wild point.

1. Ralph H. Fox and Emil Artin, *Some Wild Cells and Spheres in Three-dimensional Space,* Annals of Mathematics **49** (October 1948), no. 4, 979–990.

L O C A T I O N S

Alexander Horned Wild Sphere, Silicon Bronze, 10″ × 8″ × 6″, Limited Edition of Eight, 1988, Collections: 1/8, Don and Jean Davis, Bethlehem, Pennsylvania; 2/8, James W. and Ardyth Cannon, Provo, Utah; 3/8, Lenore and Manuel Blum, Berkeley, California; 4/8, Bob Williams and Karen Uhlenbeck, Austin, Texas; 5/8, William and Jean Donaldson Mahavier, Decatur, Georgia; 6/8, Frederick Jacobsen and Lillian Comas-Diaz, Washington, D. C.

Bivariate Cauchy Kernel, Albemarle Serpentine, two carved individual tori, polished with texture of surface filling curve and esker, surface filling maze and groove, avian: 14″ × 10″ × 7″, reptilian: 8″ × 12″ × 9″, 1993, Collection of Michael and Sandrina Range, Niskayuna, New York.

Cosine Wild Sphere, Albemarle Serpentine, Carved by Virtual Image Projection with Polished Spherical Voids, 15″ × 22″ × 9″, 1991, Collection of Artist.

Double Torus Stonehenge, Silicon Bronze, a group of twenty-eight individual bronzes arranged in a circle on an oak disk, 6″ × 32″ × 32″, 1990, Collection of Artist, on loan for exhibition to the Maryland Science Center, Inner Harbor, Baltimore, Maryland.

Eight Fold Way, Imperial Danby Vermont Marble and Albemarle Serpentine, 56″ × 54″ × 54″, Permanent Installation in Outdoor Patio, 1993, Collection of the Mathematical Sciences Research Institute, William Thurston, Director, 1000 Centennial Drive, University of California, Berkeley, California, Gift of Mitsubishi Electric Research Laboratories, Cambridge, Massachusetts.

Eine Kleine Rock Musik, III, Skull Valley Honey Onyx, Carved and Polished, 14″ × 18″ × 8″, 1986, Collection of Artist.

Jaime Escalante Award, Silicon Bronze, Black Marble, 8″ × 5″ × 3″, 1990, Limited Edition, Unnumbered but Restricted to the award given by Arco, Los Angeles, California, Collection of Arco, Jaime Escalante, thirty-nine known awardees, and one unknown thief.

Esker Trefoil Torus, White Colorado Yule Marble, with polished grooves, 14″ × 26″ × 26″, 1985, Collection of Artist.

Essential Singularity, Milled and Threaded Aluminum, Steel Bolts, 14″ × 20″ × 10″, 1973, Collection of Artist.

Figure Eight Knot Complement I, Silicon Bronze, Polished Surface and Satin Surface, 6″ × 4″ × 4″, Limited Edition of Eight, 1989, Kodachrome Flats Alabaster in collection of artist; 1/8, Pat and John Troutman, Tully, New York; 2/8, Robert W. Jernigan, Washington, D. C.; 3/8, Betty T. Bennett, Dean of Arts and Sciences, American University, Washington, D. C.; 4/8, Henry Crapo, INRIA, Paris, France.

Figureight Knot Complement, White Carrara Marble, Polished Surface and Honeycomb Texture Surface, 34″ × 24″ × 24″, 1990, Collection of Mount Holyoke College, South Hadley, Massachusetts, permanently installed in the Williston Library, visible from main circulation desk across an atrium.

Figure Eight Complement III, White Carrara Marble, Direct Carved with Honeycomb Texture and Esker, 14″ × 11″ × 7″, 1992, Collection of Artist.

Five Fold Umbilical Cord Torus, Direct Carved from White Styrofoam Block, 36″ × 36″ × 18″, 1989, Collection of Artist.

Four Identifications of a Square, Kodachrome Flats Alabaster, a group of four direct carved and polished individuals, sphere,6″ × 6″ × 6″, torus,6″ × 6″ × 3″, Klein's bottle,8″ × 6″ × 5″, Boy's surface,9″ × 10″ × 8″, 1976, Collection of Artist.

Igusa Conjecture, Albemarle Serpentine, Polished Spherical Voids, 8″ × 7″ × 4″, 1993, Collection of Jun-ichi Igusa, Johns Hopkins University, Baltimore, Maryland.

Incised Torus Wild Sphere, Silicon Bronze, Polished, Limited Edition of Eight, 8″ × 7″ × 3″, 1989, Original Albemarle Serpentine on loan to Institute for Mathematics, State University of New York, Stony Brook, New York. Collections: 1/8, Kenneth Hoffman, National Research Council, Washington, D. C.; 2/8, Doris J. Schattschneider, Moravian College, Bethlehem, Pennsylvania.

Joined Trefoil Figure Eight Esker Complement, Albemarle Serpentine, Direct Carved and Polished, 18″ × 16″ × 10″, 1989, Collection of Alex Polsky and Joan Rambo, Baltimore, Maryland.

Three Knots, Silicon Bronze, a group of four individual bronzes, 4″ × 16″ × 16″, 1990, Collection of Lawrence Zalcman, Bar-Ilan University, Ramat-Gan, Israel.

Three Spheres, Silicon Bronze, group of three individuals, 8″ × 16″ × 9″, each 8″ × 5″ × 3″, 1987, Collection of Artist.

Thurston's Hyperbolic Knotted Wye I, White Carrara Marble, Polished Honeycomb Texture, 13″ × 17″ × 13″, 1990, Collection of Artist.

Thurston's Hyperbolic Knotted Wyes, II, Carrara Marble, Carved with Hyperbolic Honeycomb Surface Textures, 65″ × 32″ × 30″,

1991, Collection of Geometry Center, National Science and Technology Research Center for Computation and Visualization of Geometric Structures, University of Minnesota, Minneapolis, Minnesota.

Torus with Cross-Cap and Vectorfield, Carrara Marble, Carved with Polished Grooves, 34″ × 32″ × 18″, 1986, Collection of the American Mathematical Society, Providence, Rhode Island, Gift of the Mathematical Association of America, Washington, D. C.

Torus with Cross-Cap and Vectorfield, II, Colorado Yule Marble, Carved with Polished Grooves, 23″ × 29″ × 9″, 1986, Collection of Artist.

Torus with Cross-Cap, Silicon Bronze, Polished, 7″ × 8″ × 4″, Limited Edition of Eight, 1989, Collections: 1/8, Cathy Lindbergh-Tang, Fairfax, Virginia; 2/8, Collection of Artist, on loan to SUMMA, Minorities in Mathematics, Washington, D. C.; 3/8, Shane and William Pendergrass, Columbia, Maryland.

Transversality, Albemarle Serpentine, Direct Carved, Differentially Chiseled and Polished, 20″ × 20″ × 12″, 1992, Collection of Artist.

Umbilic Torus NC, Silicon Bronze, Antique Green Patina, 24″ × 24″ × 7″, enveloping torus size is 27″ × 27″ × 9″, Limited Edition of Twelve, 1988, Collections: 1/12, The Mathematical Association of America, 1529 Eighteenth Street N.W., Washington, D.C. 20007, Gift of James Timourian, Alberta, Canada; 2/12, Syracuse University, Department of Mathematics, Syracuse, New York, Gift of James Timourian, Alberta, Canada; 3/12, The University of California at San Francisco, Medical School Library, Parnassus, San Francisco, California, Gift of William and Elizabeth Reinhardt, Walnut Creek, California; 4/12, Mitchell and Robin Melamed, Chicago, Illinois; 5/12, David and Karen Stoutemeyer, Soft Warehouse, Honolulu, Hawaii; 6/12, Roland E. Larson, Larson Texts, Inc., Erie, Pennsylvania, Gift of D. C. Heath, Lexington, Massachusetts.

Umbilic Torus NC, silicon bronze, antique green patina, 14″ × 14″ × 4″, Limited Edition of Twelve, 1989, Collections: 1/12, Heinz Götze, Springer-Verlag, Heidelberg, Germany; 2/12, John and Barbara Neuberger, Denton, Texas; 3/12, Gary Moscarello, Pasadena, California; 4/12, Dai-ichi Pure Chemical Company, Tokyo, Japan, Gift of William J. Rutter, Chiron Corporation, Emeryville, California; 5/12, Lawrence Zalcman, Bar-Ilan University, Ramat-Gan, Israel; 6/12, Richard M. and Carolyn Pass Susel, Baltimore, Maryland.

Umbilic Torus NC, silicon bronze, antique green patina, 9″ × 9″ × 3″, Limited Edition of Eight, 1991, Collections: 1/8, Gary Graf, Denver, Colorado; 2/8, Office of Technology Assessment,

John Gibbon/Director, Congress of the United States, Washington, D. C.; 3/8, Phil and Pat Church, Syracuse, New York; 4/8, Stephen J. Willson, Ames, Iowa; 5/8, Joan and Jim Leitzel, Lincoln, Nebraska.

Umbilic Torus SRC, Albemarle Steatite, Carved by Virtual Image Projection and Polished, 28″ × 28″ × 12″, 1991, Collection: Supercomputing Research Center, Bowie, Maryland, division of Institute of Defense Analyses, Alexandria, Virginia.

Umbilic Torus NIST, White Carrara Marble, Carved by Virtual Image Projection and Polished, 18″ × 18″ × 9″, 1990, Collection: Heinz Götze, Springer-Verlag, Heidelberg, Germany.

Whaledream ii + i, Albemarle Serpentine, Carved and Polished, 31″ × 13″ × 9″, 1989, Collection of Artist.

Whaledream II, White Carrara Marble, Satin Surface, 24″ × 30″ × 15″, 1987, Collection of Artist, on loan to Harold B. Lee Library, Brigham Young University, Provo, Utah, near main circulation desk.

Wild Ball, Wild Tree, Silicon Bronze, two individuals, ball 7″ × 7″ × 7″, tree 10″ × 9″ × 5″, 1987, Collection of Artist.

Wild Singular Torus, White Carrara Marble, Carved with Polished Grooves, 62″ × 22″ × 18″, 1988, Collection of Mary and Drew Major, Orem, Utah.

Mathematics in Stone and Bronze, New York Academy of Sciences, 2 East 63rd Street, New York, New York, Claire Ferguson/Curator (2 May 1991 – 16 July 1991).

Theorems in Stone and Bronze, The Marsh Gallery, Modlin Fine Arts Center, University of Richmond, Richmond, Virginia, Richard Waller/Director, Curator (10 October – 10 November 1991).

Mathematics in Stone and Bronze, Mathematical Association of American, Polya Building, 1529 18th Street, Washington, D. C., Maureen Callanan/Coordinator, Claire Ferguson/Curator (November 2 – December 10, 1990).

Theorems in Bronze and Stone, DuBois Gallery, Maginnes Hall, Lehigh University, Bethlehem, Pennsylvania, Ricardo Viera/ Director, Curator (January 18 – February 28, 1991).

Mathematics in Stone and Bronze, Hopkins Hall Gallery, Ohio State University, Columbus, Ohio, Prudence Gill/Director, Claire Ferguson/Curator (5–10 August 1990).

Through My Window, David Edlefsen/Director, Cheryl Snowden/Curator, Anchorage Museum of History and Art, Anchorage, Alaska (June 13, 1993 – May 15, 1994).

Language of Symbols, Rebecca Haines (Bloxham) / Curator, B. F. Larson Gallery, Harris Fine Arts Center, Brigham Young University, Provo, Utah (February 17 – March 18, 1984).

Carved, Cast and Constructed, Sally Fowler/Curator, The Kornbluth Gallery, Fairlawn, New Jersey (October 7 – 28, 1990).

Rocky Mountain Artists, Gwen and Charles Latterner/Directors, Old Town Gallery, Park City, Utah (February 18, 1988 – September 12, 1989).

New Art Media, Judith Oak Andraka/Curator, Marlboro Gallery, Prince George's Community College, Largo, Maryland (22 March – 6 April, 1993).

Computer Art in Context, Marc Resch and Copper Giloth/ Curators, SIGGRAPH'89 Art Show, Computer Museum, Boston, Massachusetts, June 30, 1989 – January 5, 1990; International Traveling SIGGRAPH'89 Art Show, Patric Prince/Curator, Castellani Art Museum, 5 September - 31 October 1990, Niagara University, Niagara, New York; Instituto de Estudios Norte Americanos, 20 febrero - 9 marc 1990, Barcelona, Spain; Museo de Salamance, del 11 al 22 Mayo, 1990, Salamanca University, Salmanca, Spain; Cal State University of Stanislaus, 11 March – 19 April 1991, Terlock, California.

The Tactile Show, Richard Zandler/Director, Curator, Main Gallery, Montpelier Cultural Arts Center, Laurel, Maryland, (June 5 – August 20, 1992).

Infinite Illusions, The World of Electronically Created Imagery, Richard Childers and Chris Baker/Organizers, Joan Truckenbrod/Coordinator, Joanne Gigliotti/Curator, S. Dillon Ripley Center, The Smithsonian Institution, Washington, D. C. (10 September through 10 October 1990).

BIBLIOGRAPHY

Armstrong, *Craven, Feder, Haskell, Krauss, Robbins, Tucker.* David R. Godine, Publisher, in association with the Whitney Museum of American Art. New York, 1976.

Beardsley, John. *A Landscape for Modern Sculpture Storm King Art Center.* Photographs by David Finn. New York: Abbeville Press Publishers.

Boorstin, Daniel J. *The Creators, A History of Heroes of the Imagination.* New York: Random House, 1992.

Braziller, George. *Sign Image Symbol* edited by Gyorgy Kepes. New York, 1966.

Campbell, Joseph. *The Hero with A Thousand Faces.* Princeton, New Jersey: Princeton University Press, 1973.

————. *Occidental Mythology, The Masks of God.* New York: Penguin Books, 1976.

————. *Oriental Mythology, The Masks of God.* New York: Penguin Books, 1976.

Campbell, Joseph, and Bill Moyers. *The Power of Myth.* New York: Doubleday, 1988.

Campbell, Joseph. *Primitive Mythology, The Masks of God.* New York: Penguin Books, 1976.

Clark, Kenneth. *Civilization: A Personal View.* New York: Harper and Row, Publishers, 1956.

————. *The Nude: A Study in Ideal Form.* *A. W. Mellon Lectures.* National Gallery of Art, Washington. Garden City, New York: Doubleday and Company, 1956.

De La Croix. Tansey, Kirkpatrick. Gardner's *Art Through the Ages,* Ninth Edition. New York: Harcourt, Brace, Jovanovich College Publishers, 1987.

Dissanayake, Ellen. *HomoAestheticus, Where Art Comes From and Why.* New York: The Free Press, A Division of MacMillan, Inc., 1992.

Dorra, Henri. *Art in Perspective, A Brief History.* New York: Harcourt, Brace, Jovanovich, Inc.

Geist, Sidney. *Brancusi, A Study of the Sculpture.* New York: Hacker Art Books, 1983.

Ghiselin, Brewster, editor. *The Creative Process, A Symposium, A Revealing Study of Genius at Work.* University of California Press, Berkeley, California, 1952.

Hall, James. *Dictionary of Subjects and Symbols in Art.* New York: Harper and Row, 1979.

Hedgecoe, John, and Henry Moore. *Henry Moore.* New York: Simon and Schuster, 1968.

Hill, Anthony. *Data, Directions in Art, Theory and Aesthetics, An Anthology.* Greenwich, Connecticut: New York Graphic Society LTD., 1968.

Kemp, Martin. *The Science of Art, Optical Themes in Western Art from Brunelleschi to Seurat.* New Haven, Connecticut: Yale University Press, 1992.

King, Jerry P. *The Art of Mathematics.* New York: Plenum Press, 1992.

Mandelbrot, Benoit B. *The Fractal Geometry of Nature.* New York: W. H. Freeman and Company, 1983.

Mayer, Ralph. *The Artist's Handbook of Materials and Techniques.* New York: The Viking Press, 1962.

Meilach, Dona Z. *Contemporary Stone Sculpture Aesthetics Methods Appreciation.* New York: Crown Publishers, 1970.

Noguchi, Isamu. *The Isamu Noguchi Garden Museum.* New York: Harry N. Abrams, Inc. Publishers, 1987.

Read, Herbert. *The Art of Sculpture. A. W. Mellon Lectures in the Fine Arts, 1954, National Gallery of Art, Washington.* Princeton, New Jersey: Princeton University Press, 1977.

————. *Henry Moore.* New York:
Frederick A. Praeger, Publishers. 1967.

Schattschneider, Doris. *Visions of Symmetry
Notebooks, Periodic Drawings, and Related
Work of M. C. Escher.* New York:
W. H. Freeman and Company, York, 1990.

Shepard, Roger N. *Mind Sights, Original Visual
Illusions, Ambiguities, and Other Anomalies
with a Commentary on the Play of Mind in
Perception and Art.* New York:
W. H. Freeman and Company, 1990.

Stewart, Ian. *The Problems of Mathematics.* Oxford,
England: Oxford University Press, 1987.

Wittkower, Rudolf. *Sculpture, Processes and
Principles.* New York: Harper and Row, 1977.

REFERENCES:

Cannon, James W. 1991. *Alexander's Horned
Wild Sphere* in Silicon Bronze referred to
Mathematics in Marble and Bronze: The
Sculpture of Helaman Rolfe Pratt Ferguson,
in which the reference to J. W. Alexander,
"An Example of a simply connected surface
bounding a region which is not simply con-
nected," Proc. Nat. Acad. Sci. USA 10(1924),
8–10, and L. A. Antoine, "Sur la possibilite
détendre l'homeomorphie de deux figures
a'leur voisinages." C. R. Acad. Sci. Paris 171
(1920). 661-664, are cited. *The Mathematical
Intelligencer.* 13:1.

————. 1991. In *The Eight-Fold Way,* Imperial
Danby Vermont Marble and Virginia Serpentine,
quoting Ferguson from "Mathematics in Marble
and Bronze: The Sculpture of Helaman Rolfe
Pratt Ferguson." *The Mathematical Intelli-
gencer.* 13:1:37.

Carola Giedion-Welcker. 1960. In *Umbilic Torus
NC,* Silicon Bronze, Antique Green Patina,
quoting Brancusi in *Contemporary Sculpture*
London: Faber & Faber, 1960, p. 126.

La Croix., Tansey., Kirkpatrick. In
Whaledream ii+i, Wild Sphere, Polished
Black Steatite, quoting Rodin in *Art Through
the Ages,* Ninth Edition. New York: Harcourt
Brace Javanovich College Publishers, p. 911.

Moore, Henry 1937. In *Figure Eight Complement III,*
White Carrara Marble, quoting Moore in "The
Sculptor Speaks," *The Listener.*

Read, Herbert. 1966. In *Umbilic Torus SRC,*
Polished Serpentine quotes Herbert Read
in *Henry Moore.* New York: Frederick A.
Praeger, Inc., p. 257.

Sylvan, Gwen. In *Torus with Cross-Cap,* Polished
Bronze, Ferguson is quoted in *The Art of
Mathematics,* Pixel 6:58.

Wittkower, Rudolf. 1977. *Thurston's Hyperbolic
Knotted Wye I* quotes Boccioni's "Manifeste
technique dela sculpture futuriste" in
Sculpture, Processes and Principles. New York:
Harper and Row, p. 274.